P9-DWZ-704

# Point & Drag

By C.J. Hadley

When I went out to help on a ranch, I was never given point, the place at the head of the pack. I was told to stay with the drag. It was not a flattering post, but it was the easiest position for an amateur, and with a thousand pregnant cows of John Ascuaga's ahead of me—obviously with the slowest on the tail end—it took longer to reach the time to unsaddle. People in the drag were often dirtiest at the end of a long, dry day…and the most weary.

The pack of artists and poets we've collected for this book are all on point. Not one shows any hint of bovine dust. Some of their work is current; a few pieces go back more than one-hundred-and-fifty years.

How did we choose the poets? From twenty-nine years attending the National Cowboy Poetry Gathering in Elko, Nevada. From a collection of dozens of cowboy poetry books, hundreds of tracks on CDs, and from suggestions from the first wordsmiths we picked. And for love of language and art, awe for horses, and an appreciation for cowboys, cowgirls and ranch life.

Art director John Bardwell selected most of the artists. "What makes western art unique?" he asks. "Images of men on horseback have been around for a thousand years. Substituting a Stetson for a knight's helmet is easy enough. Except that crusaders and cavalry are long gone. But the cowboy is still quite alive." Bardwell, also an artist, was born in Indiana, grew up in Southern California, and knows that very few people will ever watch a branding or sample the fried rewards of the day. "But they might imagine driving a herd of cattle across a chest-high river and eating beans and biscuits from a tin plate, joking with saddle mates around a mesquite fire."

And while sitting around that campfire, those cowboys, cowpunchers or buckaroos are telling stories or reciting poems to entertain each other and pass the time.

The words in this book also paint pictures of life in the West. Vivid. Real. Painful. Touching. Inspirational. The messages might make you laugh, cry, or ache, but your heart will warm to this kind of company.

Western art and poetry is not about legend or pretend. "As much as some might hope for and predict western ranching's demise," Bardwell says, "in the distant future, when saddles and tack can be seen in museums

**Rock Solid, Tucson** By Nancy Boren

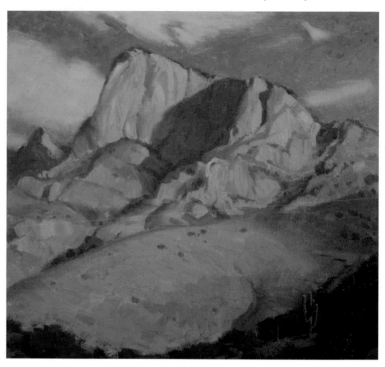

## "Where is the West? Who shall fix its limits? He who attempts it will soon learn that it is not a fixed but a floating line."

ELEUTHEROS COOKE (1787-1864)
(INTRODUCTION TO "TAMSEN DONNER:
A WOMAN'S JOURNEY" BY RUTH WHITMAN)

and we go out for a Saturday dinner of tofu t-bone, maybe somebody will drag out a dusty copy of this book and dream a little of how it might have been."

Only a small taste of great western art and poetry appears in this book, and we hope to do more, but this should be enough to get rid of your dust in the drag and share point with unique and precious artists and poets of the American West.

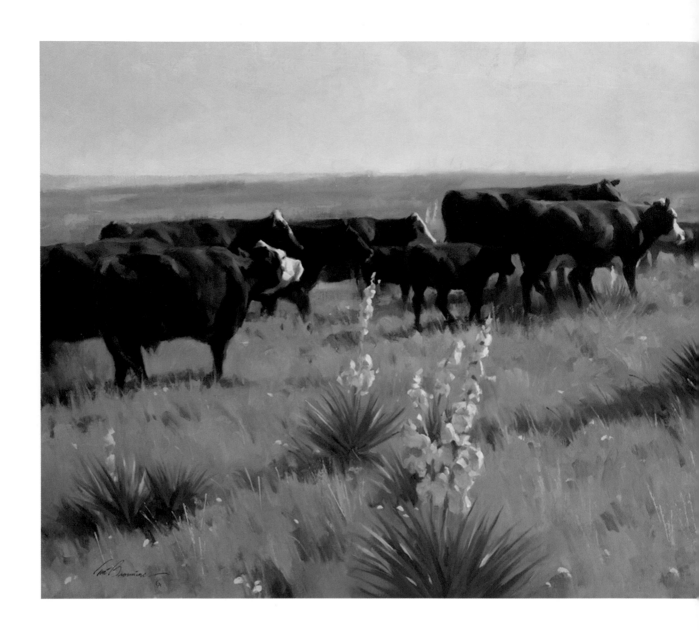

# POETS

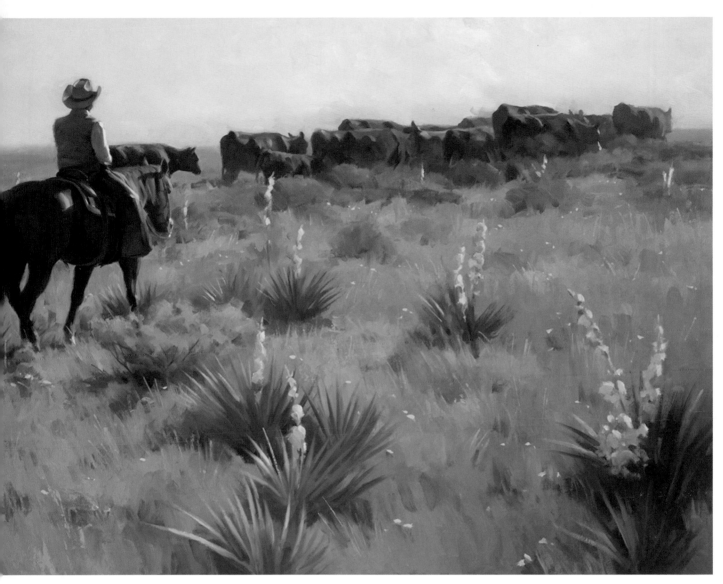

**Spring Drive**  By Tom Browning

*(Continued)*

## When Hunters Meet
By John Phelps

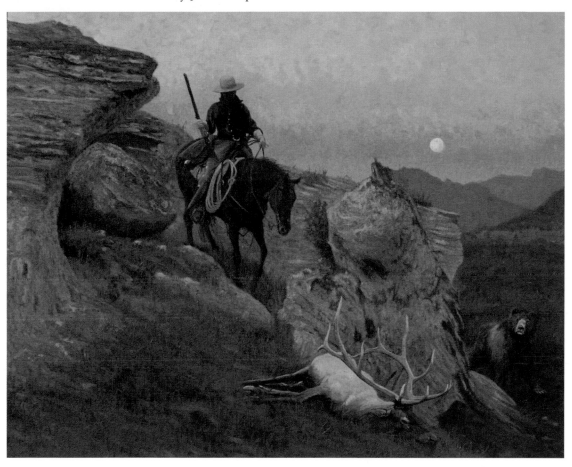

# ARTISTS

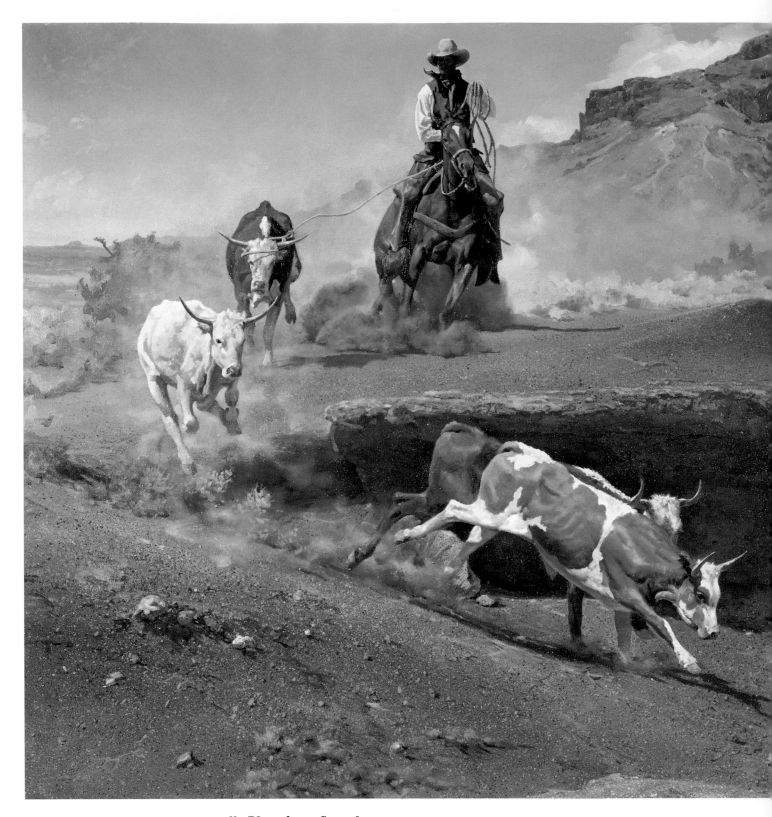

**No Place for a Gunsel**
By Bill Owen

*Bill Owen,*
*by his friend Tom Browning.*

## Two Generations
By Bill Owen

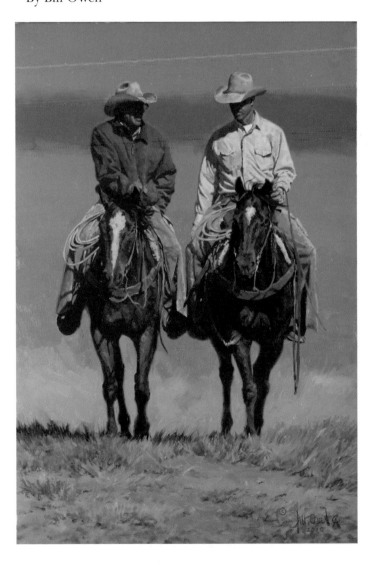

***Bill Owen*** *(1942-2013) was born in Gila Bend, Arizona, to an artist mother and cowboy father. His destiny to chronicle the cowboy life in paint and bronze was cast early. He loved his saddle time as much as he did painting and sculpting and he took great pride in having a working hand say, "That's exactly the way it is." Bill was an active member of the Cowboy Artists of America for forty years. He also founded the Arizona Cowpuncher's Scholarship Organization to help finance education for youths of Arizona's ranching community. (www.billowenca.com)*

# A Woman's Place

By Wally McRae

"A woman's place is in the home." That always has made sense.
They're just not built for riding broncs, nor fixin' barbwire fence.
The "woman's place" is well-defined throughout the cowboy West,
Besides, it's our tradition. Our old ways have stood time's test.
There's lots of things that women do way better than a man.
They're a whiz at washing diapers, or with a frying pan.
Those ladies are a comfort when a man ain't feelin' prime,
So, for cookin' or for lookin', give me a woman every time.
I've always advocated the old values of the West.
I believe, just like gospel, that the old-time rules is best.

A few years back I put things off, like I'm inclined to do.
When branding time come rolling 'round—I didn't have a crew.
And this girl, I'll call her Laurie, said she'd agree to lend a hand.
I thought she meant her husband! See, I didn't understand
That she meant *her*, you savvy now that I was in a bind.
I didn't want to break her heart. I couldn't be unkind.
She said she had these horses that needed lotsa miles.
I said we'd start at daylight. She says, "Great. And thanks," and smiles.

'Bout three o'clock next morning, while I'm still snoring hard,
I starts, and hears a creeping gooseneck ease into the yard.
We invites her in for breakfast, but she's already ate.
It's an hour and half to daybreak 'n I'm already late.
The crew shows up, but she's the one who gives me an assist
When Old Ranger tries to buck me off, she gathers cows I missed!
While I gees and haws Old Ranger, her horse rolls o'er his hocks.
She cuts us cowboys seven ways, 'n does it orthodox.

There ain't nothin' that that girl can't do! I'm feelin' like a dope.
At last in desperation, I says, "Laurie, wanta rope?"
She keeps six rasslers busy. We're all abustin' gut.
She even finds a branded bull that I forgot to cut.
For four long days she shows us how a real hand operates.
She rassles and gives shots and brands. She even "casterates"!
When we gets done I offer up to ride, to pay her back.
In the nicest way that she knows how she lets me know: I lack
Some basic skills I never learned. My horses ain't the best.
They got more help than they can use. I prob'ly need a rest.
So:
"A woman's place is in the home," to me don't seem so strange,
Because I finally figured Laurie's "Home (is) On The Range."

*(McRae wrote this poem after branding with Karla Gambill, the daughter-in-law of*
*a schoolmate, whose maiden name was Laurie. "She proved to be mighty good help.")*

# Born to be on the Stirrup Bar
By Nancy Boren

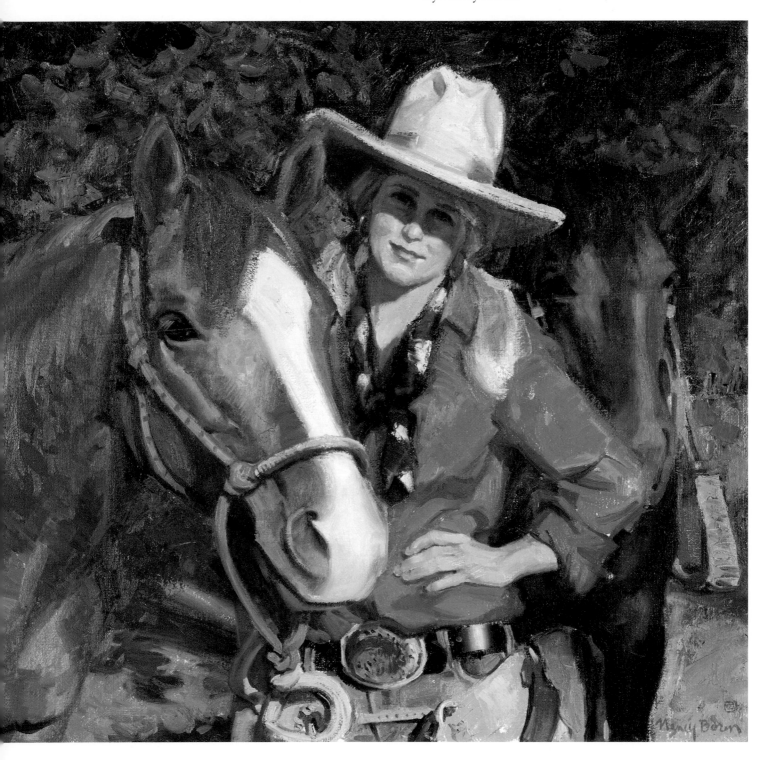

**Nancy Boren,** *Alaska born, lives in northern Texas. She was destined to become an award-winning artist. Her father, James Boren, was one of the most popular western artists of the twentieth century (see page 14). (www.nancyboren.com)*

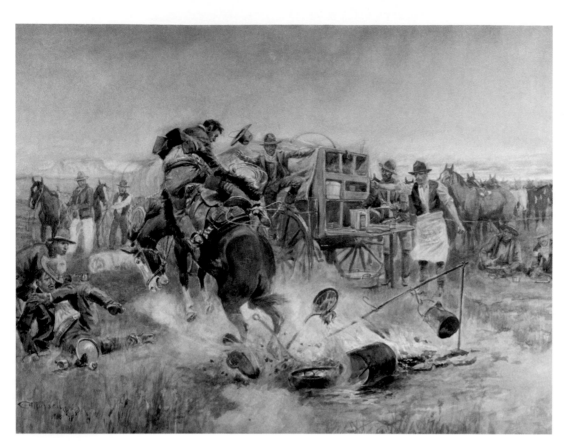

**Bronc Breakfast**
By C.M. Russell

*C.M. Russell* (1864-1926) *grew up in Missouri watching explorers and fur traders head west. At sixteen, he went to Montana, worked briefly on a sheep ranch, and then cowboyed for a number of outfits and lived with the Blood Indians. He painted more than two thousand works depicting the life and landscape of cowboys and Indians of the western United States and Canada. He was also a storyteller and author.*

# The Cook's Revenge

By Bill Jones

Cookin' ain't no easy job,
If anyone should ask.
And cookin' for a cowboy crew
Is a downright thankless task.

"The grub is cold," the boys will say,
Or else, "There's too much salt."
Any blame to pass around,
You can bet it's all my fault.

The eggs get broke and the biscuits
  burn,
The griddle won't get hot.
Try bakin' apple pie sometime,
When apples you ain't got.

One day I fixed some French cuisine,
Served fancy wine and such;
The boys all held their guts and
  moaned
They didn't like it much.

The boss, he held his plate aloft
Like he'd fished it from a sewer,
The boys described my gourmet meal
With a word that means, "manure."

They hurt my pride, them cowboys
  did,
I almost walked away.
But then again, revenge is sweet—
There'd be another day.

The answer finally came to me
In the middle of a drunk;
I'd make them ignorant cowboys
  pay—
I'd feed them boys a skunk.

So I found an old dead polecat
Layin' in the road,
Boiled him up one afternoon
Threw in a horny toad.

I piled their tin plates high that night
But much to my surprise
Them dad-burned heathens ate it all—
I could not believe my eyes.

I started once to tell 'em
The whole thing was a joke,
But they were belchin' so contentedly
And had rared back for a smoke.

"Cookie," they said gleefully,
"You finally learned to cook
Can I have the recipe?
Did you get it from a book?"

Them cowboys had no idea,
And they ain't found out yet
They was feastin' on some critters
That ought not to be et.

Yep, cookin' is a real tough job
It ain't no easy life.
And if my food you just can't eat,
Well…be glad I ain't your wife.

**Blue**
By Teresa Jordan

# Message in the Wind
By Jesse Smith

As you set and look down from the ridge
To the valley of green below,
You reach up and pull down yer lid
As a cool wind starts to blow.

Yer old pony's eyes are a-lookin',
His ears workin' forward and back.
All of a sudden you feel his hide tighten up,
And a little hump come into his back.

That hoss's a-readin' a message,
That's been sent to him on a cool breeze.
You feel yer gut start to tighten
And a shakin' come into yer knees.

You look to the right and see nothin'
You look to the left, it's the same,
Except for the birds, rabbits and squirrels,
And two hawks a-playin' a game.

But you know yer old hoss ain't a-lyin',
He's as good as you'll ever find,
And you know that old pony's tryin'
To warn you 'bout somethin' in time.

Well, you look real hard where he's lookin',
His eyes are plumb fixed in a stare.
Then you see just what he's seein',
A cub and an old mama bear.

The trail you'd a took went between them,
That old mama bear'd'a got tough.
That old pony like as not saved yer hide,
Or a life shortnin' scare, shore enough.

You watch 'em go 'cross the meadow,
And you ride on yer way once again,
You shore thank the Lord for the message,
He sent to yer horse on the wind.

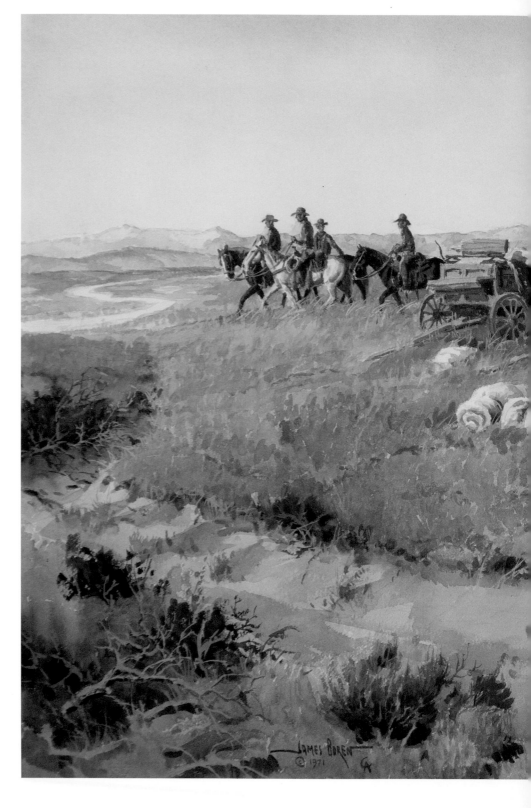

*James Boren* *(1921-1990) enjoyed
a successful commercial art career
before being appointed the first art
director of what was then called the
Cowboy Hall of Fame in Oklahoma
City. Those five years set his western
art career on a fast track and he
became an early member of Cowboy
Artists of America. He returned with
his family to his native Texas, where he
continued to paint full time. Over the
decades, he garnered scores of awards.
His work is included in corporate,
private, and museum collections.
His daughter, Nancy, is also an artist.
Her work can also be seen in this book.*

# Round-Up Time
By James Boren

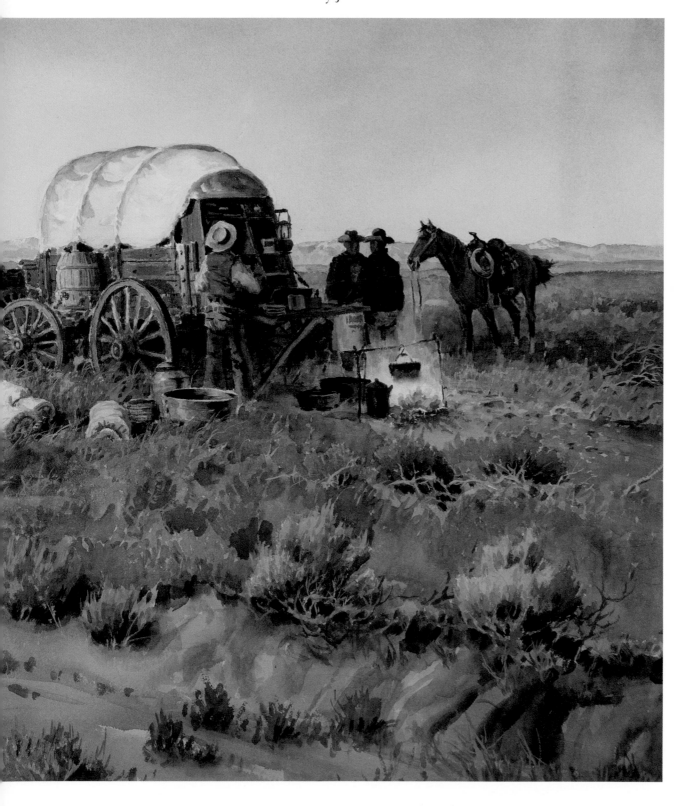

# Lead Mare

By Sue Wallis

That woman there
She can be a lead mare
Has watched horses so long
And so well she can tell what goes on
In their minds

It's that high-thrown head
How she holds her shoulders
Watch…she'll kinda hunch then
Throw her weight in ways
Unseen by us, but understood
By the saddle bunch

Once she tried it in Kentucky,
That lead mare bit
And it worked there, too
At one of those fancy outfits
White board fences
Blooded thoroughbreds
She slipped away from the crowd
Stood quiet, moved her body
And they all quit grazing
Tossed her head
And they all came to her
Just like they do

At the ranch

*Karen G. Myers returned to her native
Colorado after a decade in Alaska.
In her youth, she was a rodeo barrel racer
and enthusiastic horsewoman.
(www.karengmyers.com)*

# Horsepower By Karen G. Myers

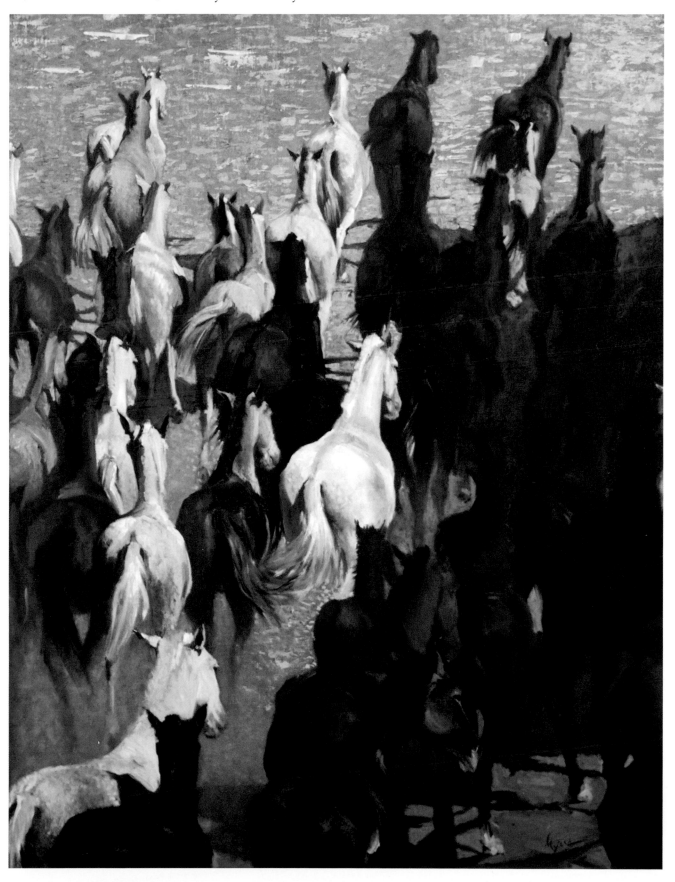

# Riding Song

By Shadd Piehl

I sit my horse
In circles
On a hill of
Half-buried stone hoops,
The forgotten remains
Of nomad lodges.
Impatient he stamps a
Red flowered cactus.
From the earth
An eagle bone whistle
Sings through the grass.
Something whispers
And I tuck it behind my ear.
Bones bleached and scattered
Tell stories of
A horse nation.
It is a good day to live
And not to grow old.
Today my pony leaves tracks
Through the past,
My heart sings a song
For yesterday
And only the hills are forever.

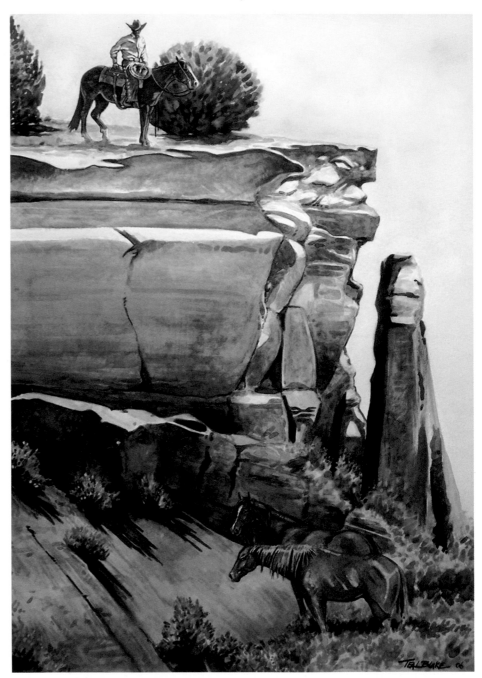

*Teal Blake* was raised in Montana cattle
country, hanging out in his father's art
studio. He lives on his family ranch in Texas.
(www.tealblake.com)

# Buckaroo
By Rod Miller

In chinks and wild rag,
Silver spurs, battered hat,
Leather cuffs, and vest
He smells of latigo,
Horse sweat, and sage,
This postcard of the West.

In hot sun, cold wind,
Rain and snow; in
Dirt and dust and mud
From first light to last
It's hide and horns, and
Shit and snot and blood.

On another man's land
And another man's horses,
Punching another man's cattle
He's unfettered and free
With no ties that bind;
Owns little else but a saddle.

## Lotsa Rope
By Dave Holl

If he tires of the scenery,
The foreman, the food, or
Some greenhorn and his braggin'
He draws his pay, rides away,
And throws his bedroll
In another outfit's wagon.

He ain't in it for money
For he'll never get rich.
And it's work not many will do.
But it's more than a job
To them that do it; it's a
Calling, and it's called Buckaroo.

*Dave Holl is a Great Basin buckaroo, illustrator,
and artist, who now runs a small ranch in
Klondyke, Arizona.*

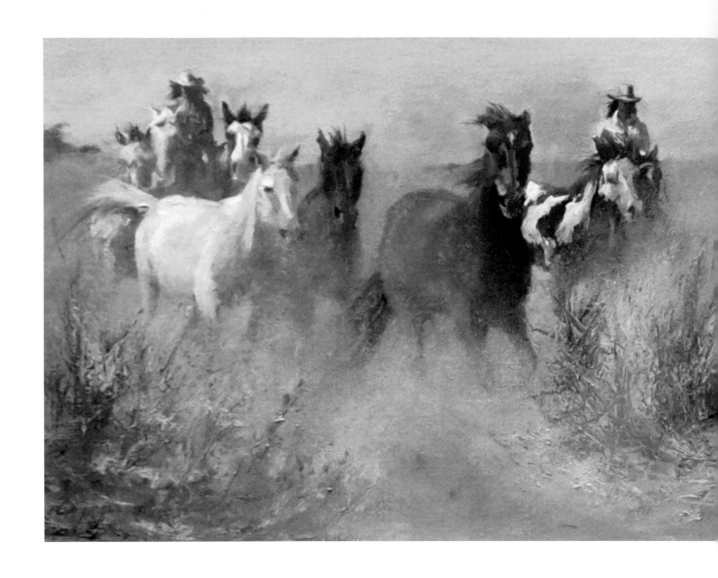

# Hoofs of the Horses

By William Henry Ogilvie

The hoofs of the horses!—Oh! witching and sweet
Is the music earth steals from the iron-shod feet;
No whisper of lover, no trilling of bird
Can stir me as hoofs of the horses have stirred.

They spurn disappointment and trample despair,
And drown with their drumbeats the challenge of care;
With scarlet and silk for their banners above,
They are swifter than Fortune and sweeter than Love.

# Cowgirls and Dust
By Karen G. Myers

On the wings of the morning they gather and fly,
In the hush of the nighttime I hear them go by—
The horses of memory thundering through
With flashing white fetlocks all wet with the dew.

When you lay me to slumber no spot can you choose
But will ring to the rhythm of galloping shoes,
And under the daisies no grave be so deep
But the hoofs of the horses shall sound in my sleep.

*Illustrations*
*By Dave Holl*

# The Buckskin Mare

By Baxter Black

He was every burnt out cowboy
That I'd seen a million times
With dead man penny eyes
Like tarnished brass
That reflected accusations
Of his critics and his crimes
And drowned them
In the bottom of a glass.

"He's a victim," said the barkeep,
"Of a tragic circumstance.
Down deep inside him,
Bad luck broke an egg.
Now his longtime compañeros
And his sagebrush confidants
All treat him like a man
Who's got the plague."

He was dang sure death warmed over,
Human dust upon the shelf,
Though Grasmere ain't
The center of the earth
He appeared like he'd be lonesome
At a party for himself
So low was his opinion
Of his worth.

"Pour me two, and make 'm doubles."
Then I slid on down the bar
And rested at the
Corner of his cage.

I had judged him nearly sixty
When I saw him from afar
But eye to eye,
I'd overshot his age.

'Cause it wasn't time that changed him,
I could see that now up close,
Pure hell had cut
Those tracks across his face.
His shaking hand picked up the drink
Then he gestured grandiose,
"This buys you
Chapter one of my disgrace.

"It was twenty years, September,
That I first laid eyes on her,
Not far from where
This story's bein' told.
She was pretty, in an awkward way,
Though most would not concur,
A buckskin filly,
Comin' two years old.

"We were runnin' wild horses
On the Blackstone range that day.
We found 'em on the flats
Right after dawn.
There was me and Tom and Ziggy,
Plus some guys from Diamond A.
They caught our scent
And then the race was on!

"We hit 'em like a hurricane
And we pressed 'em to the east
A' crowdin' 'em
Against the canyon rim
'Til the fear of God was boilin'
In the belly of the beast
And chance of their escape
Was lookin' dim.

"We all held the bunch together
And we matched 'em stride for stride
I took the flank
So none of them would stray.
Then I saw that buckskin filly
Take a trail down the side,
I rode on by
And let her get away.

"'No big deal,' I told my cronies,
As we later reminisced
And celebrated
With a glass of beer.
'She would'a made poor chicken feed,
So I'm sorta glad I missed.
I'll get her when we
Crack 'em out next year.'

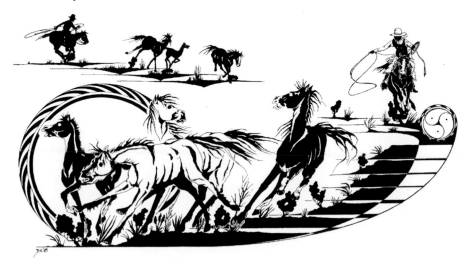

"Shor'nuf, next fall we found 'em
Up on California Crick.
The buckskin mare
Was still amongst the pack.
I had made a little wager
And I aimed to make it stick,
Whoever roped her
Pocketed the jack.

"We lined 'em out and built our loops
Then ignoring protocol,
That mare changed course
And never missed a beat!
She took dang near the entire bunch
When she climbed the canyon wall
And left us empty handed
At her feet.

"In the several years that followed
She eluded each attempt
To capture her, in fact,
She seemed amused.
And her reputation deepened,
As no doubt, did her contempt
For us, the bumbling cowboys
She abused.

"The legend of the buckskin mare,
Which to me, was overblown,
Was bunkhouse, barroom
Gossip everywhere.
She achieved a kinda stature,
Way beyond mere flesh and bond,
And stories of her deeds
Would raise your hair.

"Some attributed her prowess
To a freak in Nature's Law.
Still others said
She was the devil's spawn

So the incident that happened
At the top of Sheepshead Draw
Served notice hell's account
Was overdrawn.

"'Cause upon that fateful gather
There was one foolhardy dope,
A greenhorn kid
Who didn't have a care
But susceptible to eggin'
And right handy with a rope
So, 'course we pumped him up
About the mare.

"He was lathered up and tickin'
Like an ol' two dollar watch

When we spotted
The object of the game.
Though we wanted other horses,
Each one ached to carve his notch
On the buckskin mare,
Bruneau Canyon's fame.

"They were down amongst the willers
By a muddy water hole.
The kid went first,
He had her in his sights.
And halfway up on the other side
Where the slick rock takes its toll
He caught that buckskin legend
Dead to rights!

"He was screamin' bloody murder

As she clawed her way uphill!
He pitched the slack
And pulled his horse up hard!
She was jerked around and faced the kid,
And friend, if looks could kill
I'd have folded before
She played her card.

"But the kid began descending
With his back turned toward the mare
He planned to choke her down,
I won't deny,
But she jumped from high above him,
Like a bird takes to the air,
She looked for all the world
Like she could fly.

"Time was frozen for an instant
As she leaped out into space,
A piece from some unholy carousel
And I stared,
Slack jawed and helpless,
In the morbid scene's embrace,
Oddly peaceful,
Until the hammer fell.

"She came down like fallin' timber!
Like a screamin' mortar shell
And scattered terra firma in her wake!
She lit runnin' off his wrong side
Like a thoroughbred gazelle!
That nylon rope was hissin' like a snake!
It flipped behind the kid's own horse.
Laid the trap as sweet as pie.

(more)

"She thundered by him
Takin' up the slack!
The rope drew tight around his hocks,
Then she shifted into high
And jerked that horse
Right over on his back!
'Course the kid fell backwards with him.
In my heart I knew his fate.

"His soul was headed
For the great beyond.
She was draggin' horse and rider
Like a bundle of deadweight
When Clay rode in
And cut the fatal bond.
She escaped. That goes unspoken,
Toward the seeding to the west.

"To our dismay
The kid had breathed his last.
She had spread his brains all over,
But ol' Maxie said it best,
'That's what ya get fer tyin' hard and
    fast.'
The years creaked by like achin' joints.
Driftin' cowboys came and went.
The buckskin mare, she held her own
    and stayed.

"She became a constant rumor
And engendered discontent
Among the bucks
Whose reps had not been made.

But to me she was an omen
Like a black cat on the prowl.
I had no admiration
For her kind.

"She began to stalk my nightmares,
An obsession loud and foul
Only drinkin'
Would get her off my mind.
There were still a few ol' timers
Like Jess and Dale, Chuck and Al,
Who spoke of her
As one without a fault.

"They bragged her up,
Which didn't do a thing for my morale
'Cause I'd begun to dread
Each new assault.
But I went, like I did always,
When they organized last year.
We met at Simplot's
Sheep Crick winter camp

"Then headed east toward J P Point,
It was sunny, warm and clear
But I was cold.
My bones were feelin' damp.
It was gettin' close to lunchtime
When we finally cut their track
And found 'em at the
Bruneau Canyon's verge.

"We rode in like mad Apaches!
I was leadin' the attack!

The first to see us comin'
Was the scourge.
The scourge of all my sleepless nights
The bogeyman in my dreams.
I told myself,
This run would be her last.

"She ducked across my horse's nose,
To draw me out, it seems.
I followed suit and
Then the die was cast.
She went straight for Bruneau Canyon
Made a beeline for the edge.
My head was ringin'
With her siren's song

"Then she hesitated briefly,
Sorta hung there on the ledge
Like she was darin' me
To come along.
Then she wheeled, without a 'by yer
    leave'
And disappeared from view.
I reached the precipice
And never slowed!

"I could hear the boys shoutin'
But by then I think they knew
I was rabid
And ready to explode!
We landed like an avalanche,
My horse, a livin' landslide!
I'll never know
Just how he kept his feet.

"My boot hooked on a buckbrush limb
And whipped me like a riptide,
And in the crash,
I durn near lost my seat!
But I kept the spurs dug in him
As I held the mare in sight.
Varmints skittered,
As down the side we tore!

"There were boulders big as boxcars,
Rocks who'd never lost a fight,
That stepped aside
To watch this private war.
Then the cunning crowbait got me!
She came up to this ravine

And jumped it!
Looked to me like just for show.

"But I reined up hard and halted.
There was twenty feet between
My horse's hooves
And sure death down below.

But no horse, no fleabag mustang,
Was a match for my resolve.
I drove the steel
In my pony's hide

"'Til he leaped above the chasm!
I could feel his fear dissolve
As we sailed, soaring,
Flaunting suicide!
An eternity of seconds
That concluded in a wreck
The like of which
You've never seen before.

"Nearly cleared the far embankment,
Got his front feet on the deck
And pawed like someone
Swimmin' for the shore!
Then he shook one final shudder
And went limp between my knees.
I scrambled off him,
Prayin' not to fall.

"He'd impaled himself upon a rock
And died without a wheeze,
His guts a'stringin'
Down the crevice wall.
Then his carcass started saggin'
Slippin' off the bloody skewer.
I lunged to save my rifle
From the slide!

"My revenge was all that mattered,
A disease that had no cure
Save the stretchin'
Of one ol' buckskin's hide.
I stood up and tried to spot her
But my head was feelin' light,
I knew she might be
Hidin' anyplace.

"Then I heard some pebbles clatter
Up above and to my right
And there she waited…
Laughing in my face.
She was standin' like a statue
And was backlit by the sun.
I shook so hard
Coins rattled in my jeans.

"I could feel my heartbeat poundin'
Like the recoil of a gun.
My rowels were janglin'
Tunes like tambourines.

As I raised the shakin' rifle,
Bugs were crawlin' in my veins.
I levered in a shell
For her demise.

"A thirty-thirty center fire,
One hundred and fifty grains,
And shot'er dead…
Right between the eyes.
You could hear that gunshot echo
All the way to Mountain Home.
The rolling boom
Just seemed to stay and stay

"And it drummed its disapproval
Like a dying metronome,
A requiem
That haunts me to this day.
I climbed out of Bruneau Canyon
With my saddle and my gear.
A grizzly greeting
Filled me with despair.

"See, my so-called friends left me to rot.
The reason why, was clear,
They'd staked a cross…
In honor of the mare.

The rest, well, you can figger out.
But my daddy always said,
'You gotta play the hand
That you been dealt.'

"I done made that sow a martyr
And I wish that I was dead.
Because, my friend,
I know how Judas felt."

# Migrations

By Rod Miller

I hear them in the evening winging northward—
    Their eager, maybe longing, kind of sound.
It reminds me that we'll soon be done with calving;
    That branding time ain't far from coming 'round.

And I think how fall works really ain't that distant;
    Shipping calves under sundown pewter skies
Wherein arrowpointed flocks are winging southward,
    Trailing echoes of urgent, mournful cries.

## March to Water
### By Thomas Quinn

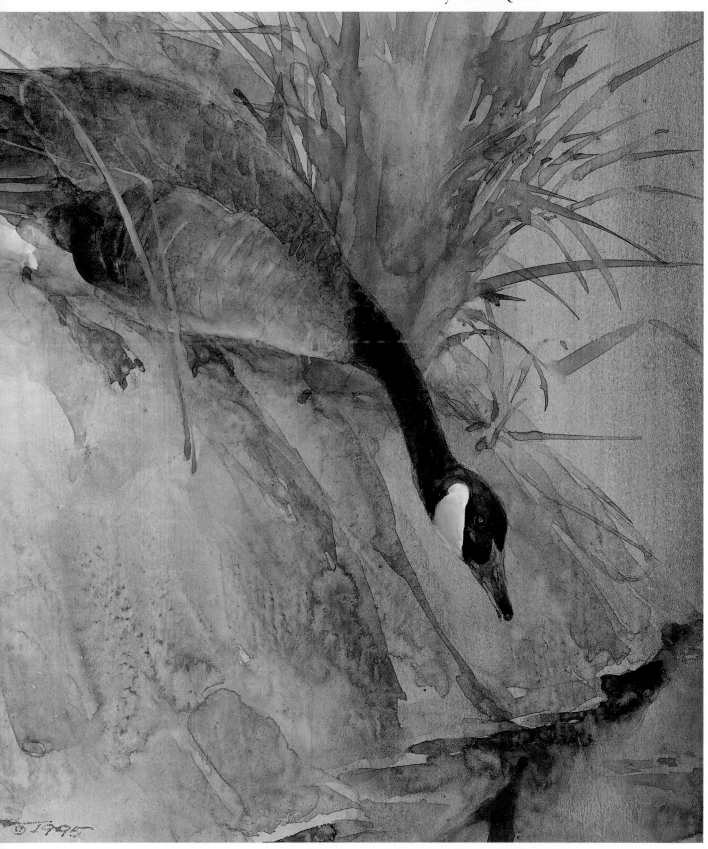

**Thomas Quinn** *lives and paints on the northern coast of California. His brother Dan is a cowboy in Montana. He graduated from the prestigious Art Center College of Design* *in Los Angeles. His book, "The Art of Thomas Quinn," can be found on Amazon or from Global Interprint in Santa Rosa, California. (www.thomasquinnart.com)*

# Black Draught

By Larry McWhorter

"Good Lord, what a dink" I thought as the boss
Said, "Put that black colt in your string."
I'd rode lots of duds but none quite compared
To this pitifully ugly, poor thing.

Taylor, he read me just like the Good Book
And probably felt the same way
But his heart beat soft for children and colts
So he took a moment to say,

"Just give 'im a chance to prove himself, son.
You asked that of me when you hired.
Find out his limits and bring 'im on slow,
Don't get him too mad or too tired.

"Just look at that eye all shiny and bright.
Now he won't win a prize in a ring
But somethin' about him I kinda like.
Out here show points don't mean a thing."

The boys were grinnin' when I roped him out
And went to the pen that was round.
My face sure got red as I pulled up my cinch
When he squealed and fell to the ground.

And thus we begun our rocky romance,
Not liking each other at all
But somehow that horse was ready to go
When we started workin' that fall.

I still hadn't stuck a tag on him yet
But name 'im I figured I ought.
There was but one thing he brought to my mind
So I dubbed him the title "Black Draught."

He'd put on some bone and muscle and fat
By the end of our third workin' season.
The boys still grinned at my little black horse
But now for a different reason.

Ever alert, he was easy to teach.
A pretty good horse he had made.
One day he even outcut Taylor's ace,
The cowboss then offered a trade.

I thought for a minute and then I said, "No."
Although it sure made me feel good.
But Hell would freeze over and pigs would fly
'Fore he packed another man's wood.

In the evening after we'd stripped kacks and fed
He'd taxi me up to the house.
No saddle, or bit, just denim on hide
Then he with a hose I would douse.

I guess you could say we made quite a team
But friends, he was far from a pet.
If things was just right or I'd fall asleep
He'd still try to pile me off yet.

One day the heirs split up the old ranch
And though I'm not adverse to change,
They'd started to ruin a good place in my mind
So I went in search of new range.

The sad time had come for good friends to part ways
So I went to tell him goodbye.
I stroked his dark hide and felt a wet cheek.
I must have got sand in my eye.

He smelled of my arm and nipped at my shirt.
He'd not seen me like this before
But the realization had just hit me square
That we'd be together no more.

I'd been, seen and done a lot of new things
In the year since I'd left him behind,
But no matter how I pushed him away
He clung to my heart and my mind.

I met an old friend in Childress one night
And though it might have been tacky,
Before I asked of his wife and his kids
I said, "Tell me Dave, how's Ol' Blacky?"

A look I'd not seen come over his face,
He reached down and got me a beer.
His hand on my back, he led me away
And said, "Let's go talk over here.

"A few weeks ago we had a big storm.
That cloud was a terrible sight.
The wind blew real hard, the thunder was loud,
The lightnin' was flashin' all night.

# Hell Freezes Over
By Steven Saylor

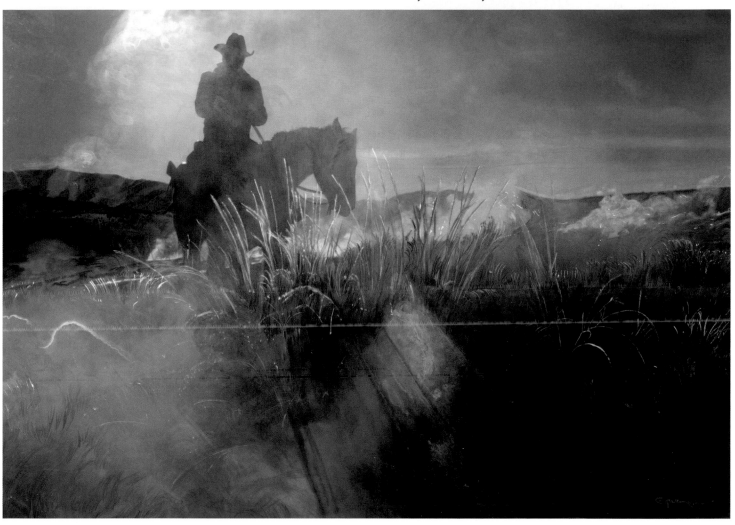

"We went out to feed the horses next day
But Blacky, who always came first,
He didn't show up with the rest of the bunch.
We started to fear for the worst.

"Taylor and I rode out there and found him.
He lay all alone on a hill.
And, Hoss, there's no good way to tell you except
To say that he's layin' there still.

"A strange thing happened with that little horse.
He sure acted good with you there
But after you left he turned for the worse.
It seemed like he just didn't care.

"He'd linger outside the bunkhouse all day
Or aimlessly wander around.
I really think he was looking for you
But you was nowhere to be found.

"Boy to see the way that little horse wilted,
It would've tore you apart.
I'll always believe that quick lightnin' bolt
Give rest to a poor broken heart."

I stood there awhile and let it soak in.
My little black horse had gone home.
I'll always wonder if he'd be alive
If I'd fought that fool urge to roam.

Good horses abound and run through my dreams
But he's the main memory I've got.
He wasn't the best but he was my ace
And I sure do miss him a lot.

If You should call me to your range, Lord,
And You have a works in the spring,
I'd sure take it kind, when you hand out the mounts
If Ol' Blacky was stuck in my string.

# The Code

By Leon Flick

I learned my ways with cattle, from the men full wise to battle.
They used snaffle bit, and hackamore, and spade.
They were eager, brass, and bold, as were the stories that they told.
And also were the horses that they made.

They sang a tune to leather creakin', and their spur rowels softly speakin'.
As their horses trotted rhythm in the sage.
They were horse of leg and bone, that could trot a man back home,
After thirty miles behind 'em, on a voyage.

Men of cowboy rules, from the old vaquero schools.
Each man rode his spot based on position.
If it was on your side, that's the country you would ride.
It was expected of all without exception.

You never crossed in front, and you seldom rode behind.
And if you did, it was with social graces.
You held the spot that you'd been given, and there wasn't much forgiven
With men who were always tradin' places.

You went out there as a team, and you made your plans and schemes,
But it was still the cow that cut the final deal.
Where and how is what they'd tell, and they'd blow your plans to—
Well, a good crew just adjusted to the feel.

Every person packed a knife, that you trusted with your life.
And you hoped that they could reach you if need be.
'Cuz if you got fouled and tied to some spooked and kickin' snide
Your pardner's all that saved eternity.

You trusted one another, and you counted on the other
To take up slack, or give a little room
For your life depended on it, and your pardners in this sonnet,
Like as not, are like some sitting in this room.

Men of plenty savvy, and their horses in the cavvy
Were just as much a measure of their pride.
Their string of horses, theirs alone. To ride another man's unknown
Unless the deal'd been cut before the ride.

They gave their colts the time they needed, subtle cues and lessons heeded
Wasn't long before they gave their heart and try.
Gentle hands of give and take, trying always not to break
The spirit that would pack them till they'd die.

## Winter Work
By Bill Owen

They strung their cows like siphoned water, and a feller
    knew he oughta'
Keep the sides tucked in and leave the drag alone.
'Cuz if you push and pound, it'll only slow you down,
And it won't be long till baby calves go home.

Oh those days of brush and saddle, as you tended
    to the cattle.
How it felt as you all trotted as one crew.
Out on some sagebrush range, far away from strife and
    change,
Give me five good colts and let me buckaroo.

**Light of Day**
By Ann Hanson

**Old Faithful**
By Ann Hanson

***Ann Hanson*** *grew up in Wyoming where she*
*still lives surrounded by ranching families.*
*(www.annhanson.com)*

# Range Fire

By Baxter Black

Lightning cracked across the sky like veins on the back of your
   hand.
It reached a fiery finger out as if in reprimand
And torched a crippled cottonwood that leaned against the sky
While grass and sagebrush hunkered down that hellish hot July.

The cottonwood exploded! And shot its flaming seeds
Like comets into kerosene, igniting all the weeds.
The air was thick as dog's breath when the fire's feet hit the
   ground.
It licked its pyrogenic lips and then it looked around.

The prairie lay defenseless in the pathway of the beast.
It seemed to search the further hills and pointed to the east,
Then charged! Like some blind arsonist, some heathen hell
   on wheels
With its felonious companion, the wind, hot on its heels.

The varmints ran like lemmings in the shadow of the flame
While high above a red-tailed hawk flew circles, taking aim.
He spied a frazzled prairie dog and banked into a dive
But the stoker saw him comin' and fricd 'em both alive!

It slid across the surface like a molten oil slick.
It ran down prey and predator…the quiet and the quick.
The killdeer couldn't trick it, it was cinders in a flash.
The bones of all who faced it soon lay smoking in the ash.

The antelope and cricket, the rattlesnake and bee,
The butterfly and badger, the coyote and the flea.
It was faster than the rabbit, faster than the fawn,
They danced inside the dragon's mouth like puppets…
   then were gone.

It offered up no quarter and burned for seven days.
A hundred thousand acres were consumed within the blaze.
Brave men came out to kill it, cutting trail after trail
But it jumped their puny firebreaks and scattered 'em
   like quail.

It was ugly from a distance and uglier up close
So said the men who saw the greasy belly of the ghost.
It made'm cry for mama. Melted tracks on D-8 Cats.
It sucked the sweat right off their backs and broke their
   thermostats.

It was hotter than a burning brake, heavy as a train,
It was louder than the nightmare screams of Abel's brother,
   Cain.
It was war with nature's fury unleashed upon the land
Uncontrollable, enormous, it held the upper hand.

The men retrenched repeatedly, continuously bested
Then finally on the seventh day, like Genesis, it rested.
The black-faced firefighters stared, unable to believe.
They watched the little wisps of smoke, mistrusting their
   reprieve.

They knew they hadn't beaten it. They knew beyond a doubt.
Though News Break told it different, they knew it just went
   out.
Must've tired of devastation, grew jaded to the fame.
Simply bored to death of holocaust and walked out of the
   game.

You can tell yourself…that's crazy. Fire's not a living thing.
It's only chance combustion, there's no malice in the sting.
You can go to sleep unworried, knowing man is in control,
That these little freaks of nature have no evil in their soul.

But rest assured it's out there and the powder's always primed
And it will be back, you know it…it's only biding time
'Til the range turns into kindling and the grass turns into
   thatch
And a fallen angel tosses out a solitary match.

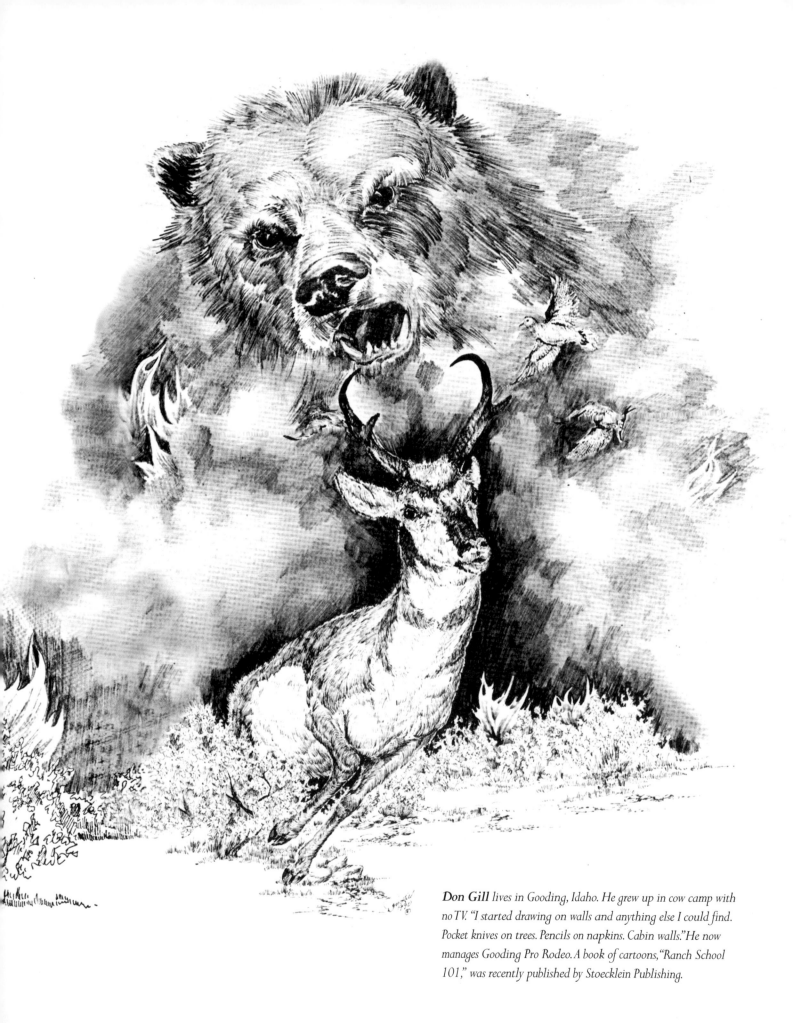

**Don Gill** lives in Gooding, Idaho. He grew up in cow camp with no TV. "I started drawing on walls and anything else I could find. Pocket knives on trees. Pencils on napkins. Cabin walls." He now manages Gooding Pro Rodeo. A book of cartoons, "Ranch School 101," was recently published by Stoecklein Publishing.

## When Dallies Slip
By J.N. Swanson

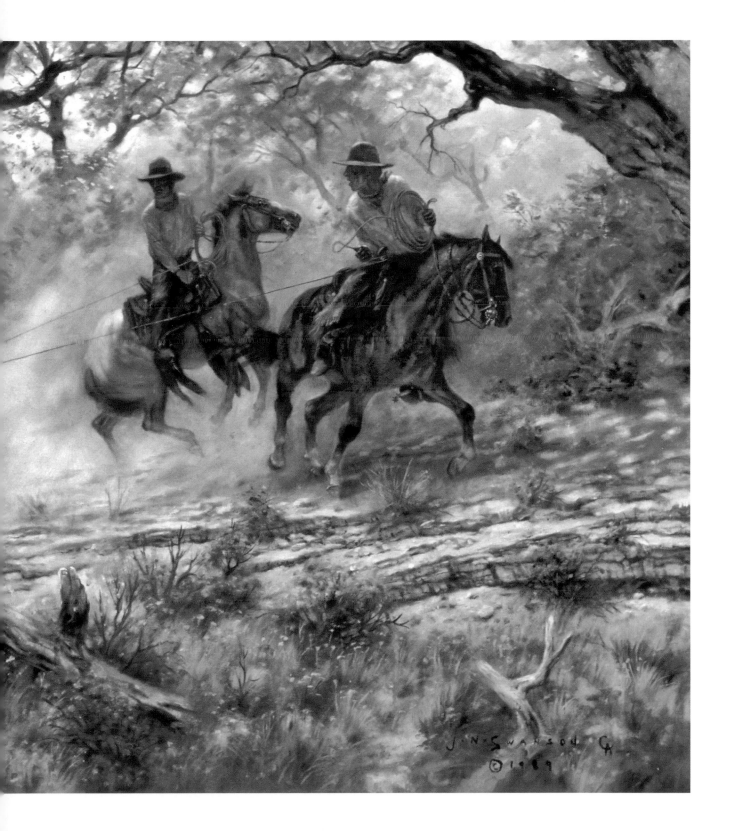

**J.N. "Jack" Swanson** *worked cattle in his youth and has raised and trained horses most of his life. He paints from memory and some imagination. He is an emeritus member of the Cowboy Artists of America. He lives in central California. (www.jnswanson.com)*

**The Idea**
By Vel Miller

# The Real Dirt on Elmer
By Waddie Mitchell

Elmer really isn't liked much by us neighbors or his peers
For he's pulled his shady dealings and shenanigans for years
Still, we all felt sorry for him when the news had got around
That chemotherapy's the reason he was sheddin' hair and pounds.

So we all pitched in and made sure chores around his ranch got done
And if things in town were needed, one of us would make the run
And, the women did his laundry, cooked his meals and brew'd his tea
For, as sorry as he is, he's part of our community.

Then, one day my wife came to me, said that she and Elmer talked
And, for all that folks had done for him, at saying thanks, he balked
But, an envelope I'd left him was the thing that he believed
To be the most important present that he ever had received.

You see, I'd given him nine coupons to Hank's Day Spa, Bar & Lodge
Each one good for one free mud bath and one deep tissue massage
He claimed he hadn't aimed to use them, fact, he almost threw
    them out
Until he heard it cured most anything from hemroids to the gout.

The local Indians believe that mud has magic healing powers
And whenever they got sick or hurt they lay in it for hours
Plus, the doctor had just told him that the chemo wasn't working
So it couldn't hurt to try it 'cuz Ol' Death was right there lurking.

So he went and first Hank had him strip and lay down on this cot
Then with his big rough, calloused hands, he squished out
    all the knots
Then, he poked his thumbs down through the meat and traced
    along the bone
While Elmer screamed and pleaded, gasping air through painful
    groans.

When that torture session ended and Elmer's laying sore and red
Hank completely covers him with mud, and this is what he said,
"I ain't never been one to believe in silly ancient lores
But, I'm convinced I feel the cancer being sucked out through
    my pores."

He went back eight more times for that same treatment every day,
And he's convinced it is the reason that his cancer went away
And though his doctor only pooh-poohs the whole story as absurd
He cannot explain the hows or whys of Elmer being cured.

My wife then took my hand and squeezed, her eyes welled up
    with tears
And said, "At times you still surprise me, even after all these years
'Cuz those coupons you gave Elmer, though not really
    commonplace
Just might have been the thing that proved to be his saving grace."

Now, leaving well enough alone is something I ain't learned
I s'pose I could have just accepted her kind praises, falsely earned
But no, for once, I had to fall back on the teachings of my youth
And I sure ruined that nice moment by my telling her the truth.

See, I'd been given them ten coupons by some hippy-looking folk
That I let camp down by the creek once, but it proved a sorry joke
For after Hank massaged me once, there's no doubt in my head
That rather than go through that again, I'd just as soon be dead.

And as for that there mud bath, I guess all I have to say
Is, it seeped in my nooks and crannys and some's in there yet today
Look, I'd no idea it would cure him, I just thought it couldn't hurt
For him to practice laying still…while covered up with dirt.

**Faithful Pals**
By Vel Miller

# Smart Dogs

By E.J. Kirchoff

The talk in Wilbur's stable was of dogs
that fellers had.
Was some sure dandy good ones
and some others that were bad.

Ol' Smokey Jones said, "Whippersnapper
is the best old dog
I've ever had for herdin' cows
or movin' of a hog."

Old Deacon said, "That komadore
I got for guardin' sheep
Sure keeps away the kiotes
and I don't lose any sleep."

Another feller had a dog
was good for huntin' bear.
Another had a dandy
puttin' pheasants in the air.

Old Bill said, "Reckon Shaggerboy
is smart as any are.
He always likes to bark when
someone drives up in a car.

"And in the house he likes to park
right in my easy chair.
I'd just go to the window
when I'd want him outa there.

"And say, 'A car's a comin',
wonder what they're comin' for.'
And he'd jump down off my chair
and go a-barkin' for the door.

"Then I would take my easy chair
and ketch up on the news—
A-readin' of the paper,
or perhaps I'd take a snooze.

"The other day I'm restin',
relaxed in my easy chair.
That dog runs to the window
and he goes to barkin' there.

"Well, I got up to look.
wasn't no one comin' there.
I turned around, and that dang dog
was in my easy chair."

*Vel Miller and husband, Warren, own a central coast ranch in California where they raise Texas longhorns and quarter horses. She attended the Art League of Los Angeles, studying under Hal Reed and Max Turner, and later taught there. A mentor, Joe DeYong, a protégé of Charlie Russell, encouraged and inspired her with his stories and love of the Old West. In painting and sculpting, she concentrates on the more emotional view of the West. She says, "I want the person who views my work to see something they have experienced themselves, or to feel a mood that brings them happiness." (www.velmiller.com)*

# What's a Bronco?

By S. Omar Barker

They asked me "What's a bronco!"
    since they seemed to crave to know.
I kinder chawed it over,
    then I fed it to 'em slow.

"A bronc," I says, judicious,
    "which is what you mean, no doubt,
Is an equine son of cyclones
    with the hairy side turned out.
His soul is filled with cockleburs,
    and when this inward itch
Bursts forth in outward action,
    he is said to buck or pitch,
Which means he comes unraveled,
    paws the moon to make it spin,
And agitates his muscles
    like he aimed to quit his skin.

"One jump he views his belly,
    and the next he chins the stars.
Was you ever kicked by lightnin'?
    That's the way his landin' jars.
His color may be anything
    from black to flea-bit roan;
A sorrel, bay, or chestnut,
    he is still the devil's own
Until he's been unspizzled
    by some hairpin on his back
With two prongs hung acrost him
    and their juncture in the kack.

"A pinwheel or a r'arback
    or a circlin' pioneer,
The bronc's a widow-maker
    when he throws himself in gear.
Though he's the toughest red meat
    you will ever come across,
If you're man enough to ride him,
    then you've got yourself a *hoss*!"

# The Blowup
By Tim Cox

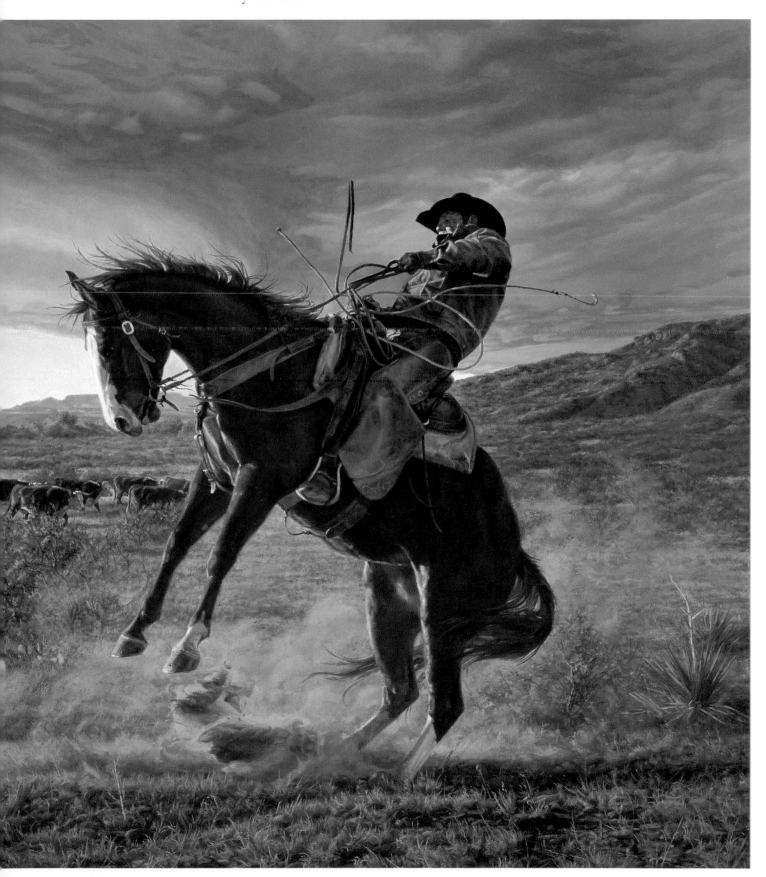

***Tim Cox*** *is a fourth-generation Arizonan. When not painting cowboys and livestock, he's out working with them. He is past president of the Cowboy Artists of America. (www.timcox.com)*

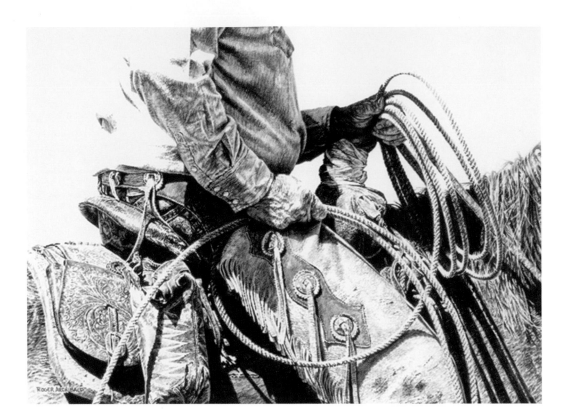

**Leather and Time**
By Roger Archibald

# By Any Other Name

By Vess Quinlan

Just short of sixty-five
Eating nitro like peppermints
Cranky and cynical
He knew firsthand
What poverty
Can do to a man
Cowboying for rich folks
Taught him what money does.

He was not impressed
With the wisdom
Of my twenty years
And said as much
The day he hired me.
He'd fired the man
Before me
For taking a shortcut
Straight uphill
With a load of salt
Spinning tires
And cutting ruts
In the spring grass.
"A man who don't care
For the country," he said,
"Can't be trusted with the stock."

I drove him into town
And listened while he
Gave hell to the Dallas doctor
Who owned our outfit
For shipping too many steers
Into a drought.
"You send one more load,"
He shouted into the pay phone,
(He always shouted at phones)
"And I will personally shoot
Every son-of-a-bitch
That walks off the truck.

"You bet you can fire me.
It won't take long neither
I can be off this ranch
Quicker'n you can lance a boil."
"Keep your truck gassed up kid,"
He said, hanging up the phone,
"We may be huntin'
Another fool to work for."
But the doctor backed down
And we stayed.

Once, when his bad heart
Put him to bed,
He let me feed the flock
Of wild turkeys.
"Take a quarter sack of corn
No more and no less
We don't want them birds
Dependin' on us.
String corn in deep snow
Close to the timber
So they can hide easy
If a coyote or a cat
Happens by.
And don't scare 'em
Sneakin' back to see 'em
Them birds is shy and spooky."

I worked for the old grump
Two whole seasons
And called him every name
I could think of
(under my breath, of course,
and downwind of his hearing aid)
Except the one he really was…
A damned environmentalist.

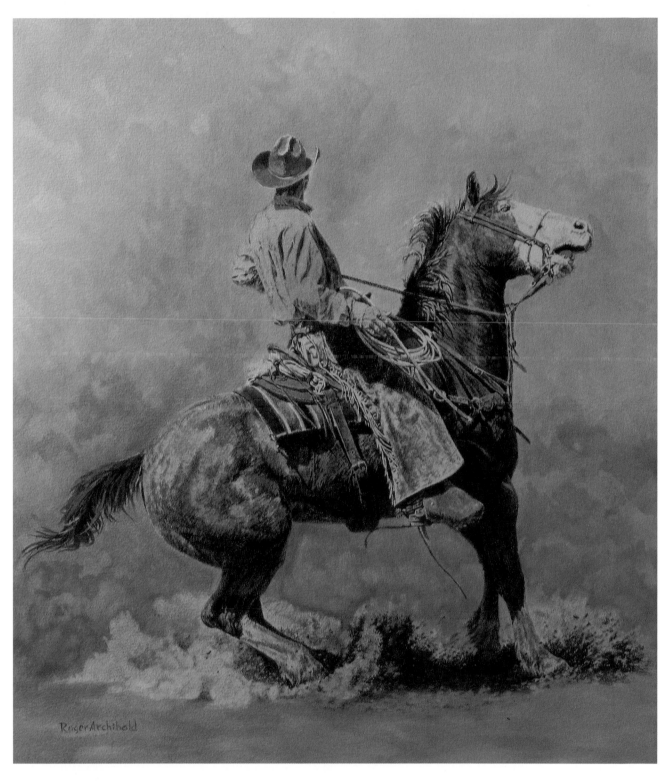

## Whoa
By Roger Archibald

**Roger Archibald** was born, raised and resides in Arizona. His early years as a working cowboy are responsible for his dedication to detail and authenticity. (www.westernpencilart.com)

# The Little Blue Roan

By Bruce Kiskaddon

Most all of you boys have rode hosses like that.
He wasn't too thin but he never got fat.
The old breed that had a moustache on the lip;
He was high at the wethers and low at the hip.
His ears always up, he had wicked bright eyes
And don't you furgit he was plenty cow wise.

His ears and his fets and his pasterns was black
And a stripe of the same run the length of his back.
Cold mornin's he'd buck, and he allus would kick
No hoss fer a kid or a man that was sick.
But Lord what a bundle of muscle and bone;
A hoss fer a cow boy, that little blue roan.

For afternoon work or for handlin' a herd,
He could turn any thing but a lizard or bird.
For ridin' outside how that cuss could move out.
He was to 'em before they knowed what 'twas about.
And runnin' down hill didn't faize him aytall
He was like a buck goat and he never did fall.

One day in the foothills he give me a break
He saved me from makin' an awful mistake,
I was ridin' along at a slow easy pace,
Takin' stock of the critters that used in that place,
When I spied a big heifer without any brand.
How the boys ever missed her I don't onderstand.
Fer none of the stock in that country was wild,
It was like takin' candy away from a child.
She never knowed jest what I had on my mind
Till I bedded her down on the end of my twine.
I had wrapped her toes up in an old hoggin' string,
And was buildin' a fire to heat up my ring.
I figgered you see I was there all alone
Till I happened to notice that little blue roan.

That hoss he was usin' his eyes and his ears
And I figgered right now there was somebody near.
He seemed to be watchin' a bunch of pinyon,
And I shore took a hint from that little blue roan.

Instead of my brand, well, I run on another.
I used the same brand that was on the calf's mother.
I branded her right, pulled her up by the tail
With a kick in the rump for to make the brute sail.
I had branded her proper and marked both her ears,
When out of the pinyons two cow men appears.

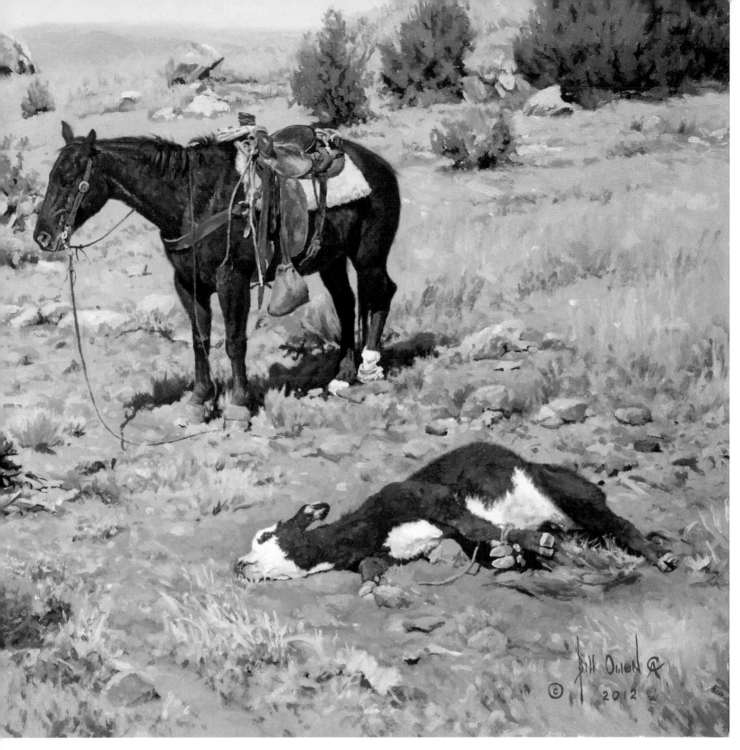

**Getting Running Iron Hot**
By Bill Owen

They both turned the critter and got a good look
While I wrote the brand down in my old tally book
There was nothin' to do so they rode up and spoke
And we all three set down fer a sociable smoke
The one owned the critter I'd happened to brand,
He thanked me of course and we grinned and shook hands
Which he mightn't have done if he only had known
The warnin' I got from that little blue roan.

**Cowboss Scattering**
By Bill Owen

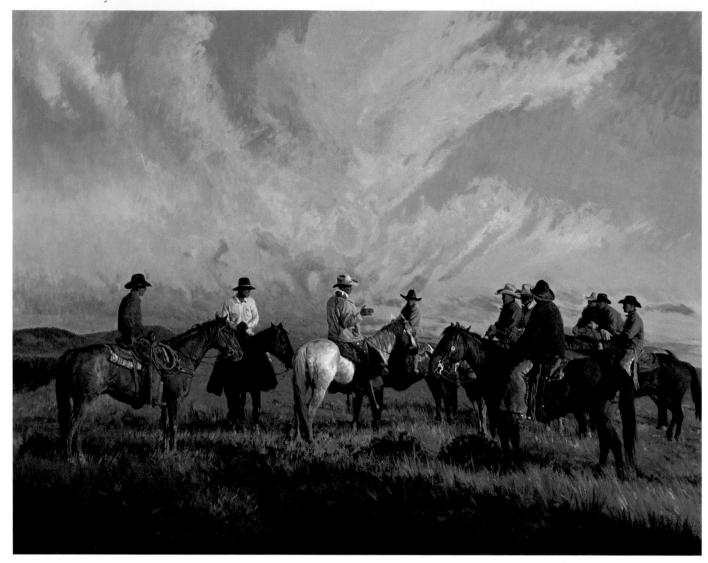

# Anthem
By Buck Ramsey

And in the morning I was riding
Out through the break of that long plain,
And leather creaking in the quieting
Would sound with trot and trot again.
I lived in time with horse hoof falling;
I listened well and heard the calling
The earth, my mother, bade to me,
Though I would still ride wild and free.
And as I flew out on the morning,
Before the bird, before the dawn,
I was the poem, I was the song.
My heart would beat the world a warning—
Those horsemen now rode all with me,
And we were good, and we were free.

We were not told, but ours the knowing
We were the native strangers there
Among the things the land was growing—
To know this gave us more the care
To let the grass keep at its growing
And let the streams keep at their flowing.
We knew the land would not be ours,
That no one has the awful pow'rs
To claim the vast and common nesting,
To own the life that gave him birth,
Much less to rape his mother earth
And ask her for a mother's blessing
And ever live in peace with her,
And, dying, come to rest with her.

Oh, we would ride and we would listen
And hear the message on the wind.
The grass in morning dew would glisten
Until the sun would dry and blend
The grass to ground and air to skying.
We'd know by bird or insect flying
Or by their mood or by their song
If time and moon were right or wrong
For fitting works and rounds to weather.
The critter coats and leaves of trees
Might flash some signal with a breeze—
Or wind and sun on flow'r or feather.
We knew our way from dawn to dawn,
And far beyond, and far beyond.

It was the old ones with me riding
Out through the fog fall of the dawn,
And they would press me to deciding
If we were right or we were wrong.
For time came we were punching cattle
For men who knew not spur nor saddle,
Who came with locusts in their purse
To scatter loose upon the earth.
The savage had not found this prairie
Till some who hired us came this way
To make the grasses pay and pay
For some raw greed no wise or wary
Regard for grass could satisfy.
The old ones wept, and so did I.

Do you remember? We'd come jogging
To town with jingle in our jeans,
And in the wild night we'd be bogging
Up to our hats in last month's dreams.
It seemed the night could barely hold us
With those spirits to embold' us
While, horses waiting on three legs,
We'd drain the night down to the dregs.
And just before beyond redemption
We'd gather back to what we were.
We'd leave the money left us there

And head our horses for the wagon.
But in the ruckus, in the whirl,
We were the wolves of all the world.

The grass was growing scarce for grazing,
Would soon turn sod or soon turn bare.
The money men set to replacing
The good and true in spirit there.
We could not say, there was no knowing,
How ill the future winds were blowing.
Some cowboys even shunned the ways
Of cowboys in the trail herd days
(But where's the gift not turned for plunder?)
Forgot that we are what we do
And not the stuff we lay claim to.
I dream the spell that we were under;
I throw in with a cowboy band
And go out horseback through the land.

So mornings now I'll go out riding
Through pastures of my solemn plain,
And leather creaking in the quieting
Will sound with trot and trot again.
I'll live in time with horse hoof falling;
I'll listen well and hear the calling
The earth, my mother, bids to me,
Though I will still ride wild and free.
And as I ride out on the morning
Before the bird, before the dawn,
I'll be this poem, I'll be this song.
My heart will beat the world a warning—
Those horsemen will ride all with me,
And we'll be good, and we'll be free.

*Prologue to "Grass." Used with permission*
*from Buck Ramsey, November 1997.*

# Yes, It Was My Grandmother

By Luci Tapahonso

Yes, it was my grandmother
who trained wild horses for pleasure
    and pay.
People knew of her, saying:
    She knows how to handle them.
    Horses obey that woman.

She worked, skirts flying, hair tied
    securely in the wind and dust.
She rode those animals hard and was
    thrown,
Time and time again.
She worked until they were meek
And wanting to please.
    She came home at dusk,
    tired and dusty,
    smelling of sweat and horses.

She couldn't cook,
my father said smiling,
your grandmother hated to cook.

    Oh Grandmother, who freed me
        from cooking.
    Grandmother, you must have made
        sure
    I met a man who would not share
        the kitchen.

    I am small like you and
    do not protect my careless hair
    from wind or rain—it tangles often,
    Grandma, and it is wild and
        untrained.

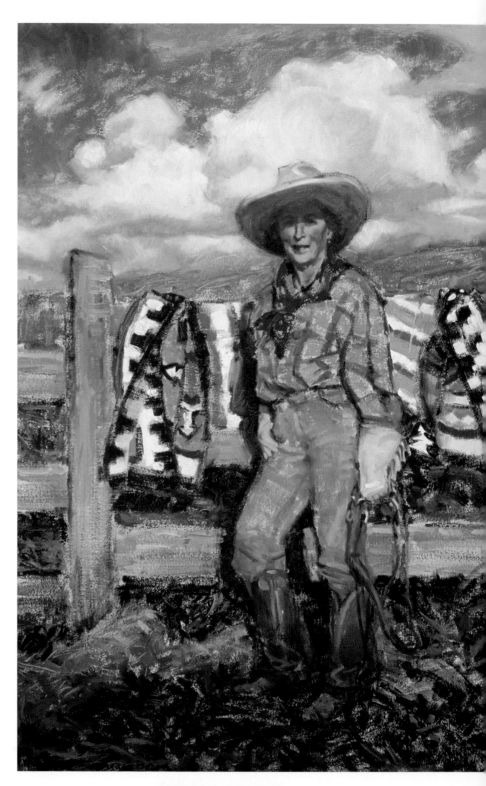

**Sixty Years a Cowgirl**
By Nancy Boren

**The Dolly Lamba**
By Teresa Jordan

# Night Lambing

By Mary Austin

"So it is that here and there, one sees a shepherd making rounds with a lantern through the night, and in a flock of three to five hundred ewes finds much to do."

Nights such as this
The bunchgrass cowers to the wind
That lies too low along the pasture
To stir the tops of trees.
The Dipper swings low from the Pole,
And changeful Algol is a beacon
In the clear space between the ranges
Above which white planets blink and peer.
The quavering of the ewes
Keeps on softly
All night.
The red eye of the herder's fire
Winks in the ash;
The dogs get up from before it,
Courting an invitation.
Great Orion slopes from his meridian,
And Rigel calls Aldebaran up the sky.

The lantern swings
Through the dark sweep of pasture,
Cool, dewy and palpitant
With the sense of this earliest,
Elemental stress of parturition.

*From "The Flock" (Chapter II) by Mary Austin, adapted by Carolyn Dufurrena.*

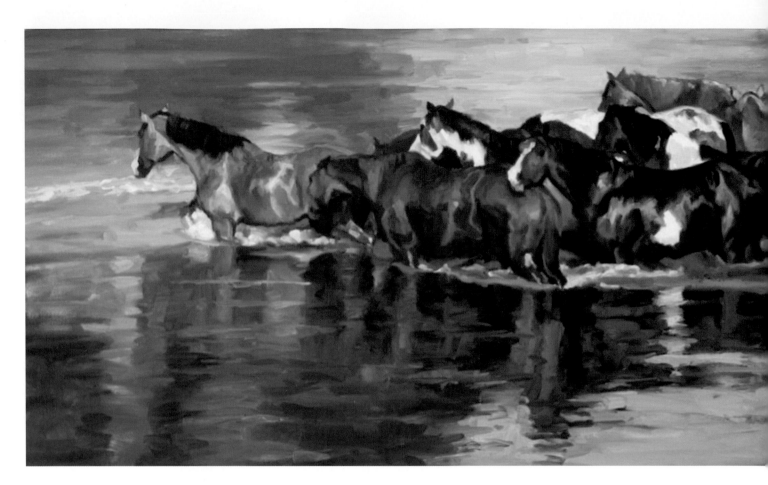

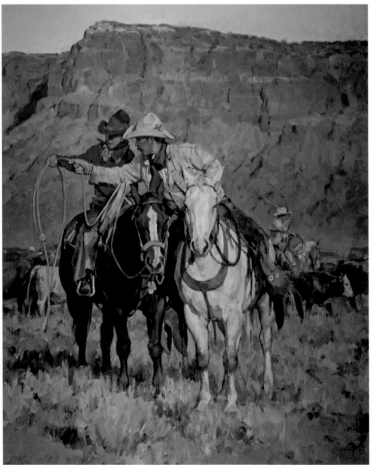

**The Mentor**
By Jason Rich

50

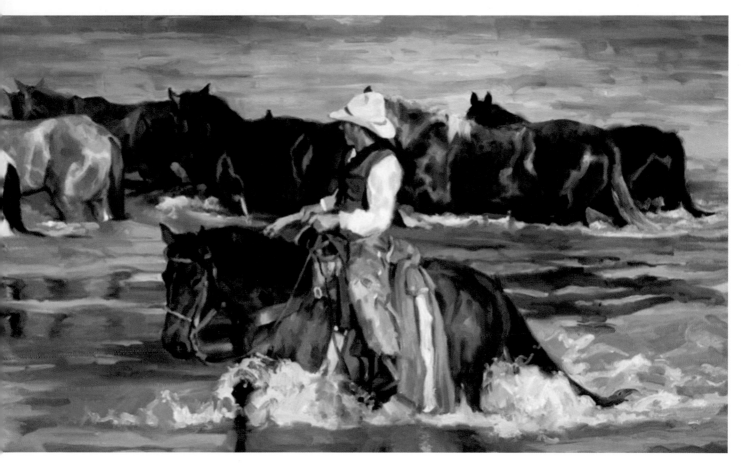

**River Reflections**
By Jason Rich

**Working the Alley**
By Jason Rich

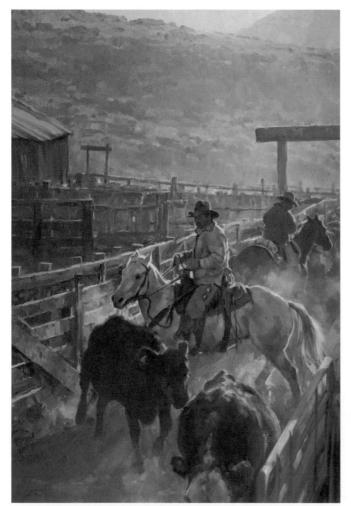

*Jason Rich* grew up in rural southern
Idaho but sought formal art training
away from home. He and his family run a
horse ranch in northern Utah. He is a
member of the Cowboy Artists of America.
(jasonrichstudios.com)

# The Red Cow

By Larry McWhorter

"I almost put my rope on her once
But then I thought it through.
I had my day in the sun long ago
So I left her for someone like you."

"Sounds to me like she run you off,"
I said to the silver-haired man.
"Why there ain't a cowbrute anywhere
Too much for a hand worth his sand."

We were talking 'bout the ol' Red Cow,
Legend 'round these parts,
And it's been said she's put fear and dread
In the punchiest cowboys' hearts.

An old barren cow who'd escaped all the drives
Because she was big, mean and clever,
The manager said she was twelve years old.
The old men said she's been there forever.

Now legends don't scare a boy of nineteen
Who thinks he's the pride of the nation
And I'm thinkin', "Now if I can pen this ol' cow
I'll sure have a good reputation.

"Where do I find this renegade beast,
This scarlet scourge of the prairie?
Why, I'll lead the hussy through the bunkhouse door.
You'll think she was raised on a dairy.

"I'll bring her in and she'll bear a grin
'Cause she'll know that she's had her lickin'
For I'm a hand from the faraway land
Where the hoot owls romance the chickens."

A gleam appeared in the old man's eye
And he was grinnin' a little too much.
"Why, I'll tell you where the Red Cow lives
And while you're gone I'll carve you a crutch.

"Oh and give me your address 'fore you leave,
You'll want me to write to your folks."
I left him there to amuse hisself,
I didn't care for his little jokes.

The Sabbath sun caught me ridin' Ol' Gus
Sneakin' through the brush like a ghost
'Til we come to the mouth of the canyon
Where the outlaw had been seen the most.

We come upon an old dirt tank
'Bout halfway up that draw
And standin' there for her mornin' drink
Was the biggest cow I ever saw.

Her horns weren't tipped, she wore no brand
Her ears were long and slick
And I thought of a big ol' rhinoceros
I'd seen in a Tarzan flick.

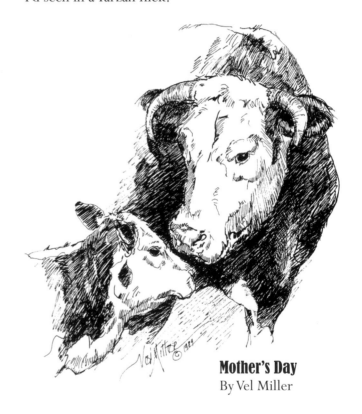

**Mother's Day**
By Vel Miller

Well, I knew if I showed myself to her now
Back up the canyon she'd go
So I eased up high so's I could drive her down
And I'd catch her in the big flat below.

Well, I cinched up a notch and shook out a loop
And pulled my hornknot tight,
Then I eased Ol' Gus to the edge of the brush
And showed myself, ready to fight.

She jerked up her head when we come in the clear
And a startled look filled her eyes.
I had to grin for my little ruse
Caught the wily Red Cow by surprise.

She's scared and confused with no place to hide.
I've wrecked her psyche, I think.
But she stood there, sized up her latest of pests,
And calmly went back to her drink.

We sat there and stared at each other awhile
'Til the Red Cow had drunk her fill
Then she stretched her back and ever so slowly
Started walkin', towards me, up the hill.

Why her stride betrayed no fear at all.
It was like she'd been through this before.
'Bout then I started to doubt my own smarts
And I pondered the Red Cow's lore.

Her slow steady walk turned into a trot
And her mouth began to foam.
The closer she got the more that I wished
That me and Ol' Gus had stayed home.

The walls of that canyon somehow looked steeper
And it looked a lot narrower too.
My perception had changed on a whole lot of things
And my brashness I started to rue.

I'd made my brag back at the ranch
'Bout the worth of a man who would balk.
Now I found myself fallen victim
To my own yappin' tongue's foolish talk.

My moment of truth was on me now
And my smarts was fightin' my pride.
The cow was locked in on me and Ol' Gus—
Then my outlook was rectified.

The boss hadn't sent me out here
On this wildcat venture, of such.
If she didn't bother him then why should she me?
Hell, one ol' Red Cow don't eat much.

Fifty feet 'tween me and the cow
Another thought entered my mind.
There were many like me but this cow that I faced
Was one of the last of her kind.

Who was I to alter her fate?
Her freedom she'd fought long to keep.
Far be it from me to ruin her life.
Oh, I could pen her, but then could I sleep?

I cringed at the thought of a grinnin' old man
And the scorn I would see in his eye,
But I knew I was right so I tipped my hat
As the famous Red Cow trotted by.

The old man was waitin' when I rode in,
The bunkhouse door open wide.
"I got things ready for you and your cow!"
A stool and a pail stood inside.

Well he rode me hard and put me up wet
'Til he seen that my pride was full peeled
But the scorn I expected he never showed.
He said, "Son, I know just how you feel.

"You ain't the first to change his mind
After doubtin' the Red Cow's lore.
Few boys your age have dealt with her kind
But on her coup stick you're just one more.

"There comes a time in every man's life
When he's forced to face his limitation.
Now you feel like a fraud but your judgment was sound
So, Son, you ain't no imitation.

"Aw, you talked a lot, but you took your shot,
Which is more than many have done.
She force fed you crow but that taste we all know
So welcome to the humbled ranks, Son."

Well, the years have gone by and I reckon she's died,
I know I never saw her again.
But with all my heart I hope that ol' girl
Never saw the inside of a pen.

And though she's gone, her legend lives on
And I'm proud to be part of her lore
For times have changed and the brute of her kind
Is rarely seen anymore.

The young sprouts now ask me 'bout the cow
And tight-throated I think of that day.
I recall my old friend and what he told me back then.
Then I grin at these pups and I say,

"I almost put my rope on her once
But then, I thought it through…"

# A Bad Half Hour

By Badger Clark

Wonder why I feel so restless;
Moon is shinin' still and bright,
Cattle all is restin' easy,
But I just kain't sleep tonight.
Ain't no cactus in my blankets,
Don't know why they feel so hard—
'Less it's Warblin' Jim a-singin'
Annie Laurie out on guard.

Annie Laurie—wish he'd quit it!
Couldn't sleep now if I tried.
Makes the night seem big and
    lonesome,
And my throat feels sore inside.
How *my* Annie used to sing it!
And it sounded good and gay

Nights I drove her home from dances
When the east was turnin' gray.
Yes, "her brow was like the snowdrift"
And her eyes like quiet streams,
"and her face"—I still kin see it
Much too frequent in my dreams.
And her hand was soft and trembly
That night underneath the tree,
When I couldn't help but tell her
She was "all the world to me."

But her folks said I was "shif'less,"
"Wild," "unsettled,"—they was right.
For I learned to punchin' cattle
And I'm at it still tonight,
And she married young Doc Wilkins,

Oh my Lord! But that was hard!
Wish that fool would quit his singin'
Annie Laurie out on guard!
Oh I just kain't stand it thinkin'
Of the things that happened then.
Good old times, and all a-past me!
Never seem to come again—
My turn? Sure. I'll come a-runnin'.
Warm me up some coffee, pard—
And I'll stop that Jim from singin'
Annie Laurie out on guard.

**Annie Laurie Wished He Would Quit**  By John Phelps

**The Girls**
By Teresa Jordan

# The Sheepherders Lament

By Curley Fletcher

I have summered in the tropics,
With the yellow fever chill;
I have been down with the scurvy;
I've had every ache and ill.

I have wintered in the Arctic,
Frostbitten to the bone;
I've been in a Chinese dungeon,
Where I spent a year alone.

I've been shanghaied on a whaler;
And was stranded on the deep,
But I never knew what misery was,
Till I started herding sheep.

The camp boss now is two weeks late,
The burro dead three days.
The dogs are all sore footed, but
The sheep have got to graze.

They won't bed down till after dark,
And they're off before the dawn;
With their baaing and their blatting
They are scattered and they're gone.

I smell their wooly stink all day
And I hear them in my sleep;
Oh, I never knew what misery was,
Till I started herding sheep.

My feet are sore, my boots worn out;
I'm afraid they'll never mend;
I've got to where a horny toad
Looks like a long lost friend.

The Spanish Inquisition might
Have been a whole lot worse,
If instead of crucifixion, they
Had had some sheep to nurse.

Old Job had lots of patience, but
He got off pretty cheap—
He never knew what misery was,
For he never herded sheep.

It's nice enough to tell the kids,
Of the big old horny ram,
The gentle soft-eyed mother ewe,
And the wooly little lamb.

'S'nice to have your mutton chops,
And your woolen clothes to wear,
But you never stop to give a thought
To the man who put them there.

The blind and deaf are blessed,
The cripples, too, that creep;
They'll never know what misery is,
For they never will herd sheep.

# Watchin' 'Em Ride

By S. Omar Barker

Isom Like was seventy-odd,
Straight in the back as a steel ramrod,
And the whiskers that growed on his leathery chin
They bristled out instead of in.
Six growed sons had Isom Like:
Jake, Joe, John, Jess, Noah and Ike.

Ridin' men was Isom's sons,
Salty, straddlin' sons-o'-guns.
Once a year they chipped in change
To pay for the best hoss on their range,
And held a ridin' to settle who
Should git that hoss when the show was through.

Nearin' eighty was Isom Like:
"Pa," said the son whose name was Ike,
"You're stiffed up like an ol' pine tree.
Better leave this to the boys an' me!"
Ol' Isom grinned his grizzled grin.
"Nope," he says. "Just count me in!"

Seven broncs in a high pole pen,
Seven saddles and seven men...
Ma Like watched as the show begun,
And when Jake straddled a dusty dun,
You guessed right off that her joy and pride
Was Jake, from the way she cheered his ride.

Jess spurred out on a big-foot bay.
Up on the fence you could hear Ma say:
"Ride him, Jess! Boy, kick him out!"
And you knowed right quick from the tone of her shout,
Of all six sons Ma Like had bore
By this here Jess she set most store.

Joe clumb on and you heard Ma squall:
"Joe, you're the ridin'est son of all!"
Noah an' John purt near got piled—
But both was Ma Like's favorite child.
Two broncs left, and the one Ike took
Bucked like the broncs in a storybook;
Pawed the moon and scraped the sky.

Up on the fence you could hear Ma cry:
"Boy, that's ridin' to suit my taste!
I got one son ain't no panty-waist!"

One bronc left, a big blue roan...
"Never mind, boys, I'll saddle my own!"
Over the saddle Pa flung his shank,
Raked both spurs from neck to flank.
The big roan rose like a powder blast,
Buckin' hard and high and fast,
But deep in the wood Pa Like set screwed,
Strokin' his beard like a southern dude!
And every time that blue roan whirled,
Ma Like's petticoats come unfurled.

Isom grinned and waved his hat,
And Ma, she squalled like a ring-tailed cat:
"Straddle him, Isom! Show your spizz!
Learn these buttons what ridin' is!"
Throwed her bonnet high in the air,
Whooped and hollered and tore her hair:
"I got six sons and nary a one
Can ride like that ol' son-of-a-gun!"
Yelled and cheered so dang intense
She fell plumb off of the high pole fence.
"Wawhoo, boys! Watch Isom spur!"
Isom's six sons grinned at her.

Seven broncs and the ridin' done...
Nary a doubt but Pa had won!
"Sons," says Ma, "are a mother's pride,
But ol' Pa Isom, *he can ride!*
The trouble is, you boys ain't tough—
But you'll learn to ride—
*When you're old enough.*"

(*Based on a true incident related by
the late Colonel Jack Potter.
Isom Like died at the age of 102.*)

## Cowboy Kid
By Buckeye Blake

**Buckeye Blake** enjoyed his childhood on the rodeo circuit
with his father and his grandfather, who bred quarter horses,
so it's no surprise that he so often depicts bucking equines.
He proudly lives on a ranch in Texas.
(www.buckeyeblake.com)

## Galloping Horseman
By Frederic Remington

*Frederic Sackrider Remington (1861-1909) was reared in upstate New York, the son of a Civil War colonel. He moved to Montana at nineteen and after his inheritance ran out, worked as an illustrator for Harper's Weekly. He became a favorite of western Army officers fighting the last Indian battles and was invited back West to make their portraits in the field and gain them national publicity.*

# Rain on the Range
By S. Omar Barker

When your boots are full of water and your hat brim's all a-drip,
And the rain makes little rivers dribblin' down your horse's hip,
When every step your pony takes, it purt near bogs him down,
It's then you get to thinkin' of them boys that work in town.
They're maybe sellin' ribbon, or they're maybe slingin' hash,
But they've got a roof above 'em when the thunder starts to crash.
They do their little doin's, be their wages low or high,
But let it rain till hell's a pond, they're always warm and dry.
Their beds are stuffed with feathers, or at worst with plenty straw,
While your ol' soggy soogans may go floatin' down the draw.
They've got no rope to fret about that kinks up when it's wet;
There ain't no puddle formin' in the saddle where they set.
There's womenfolks to cook 'em up the chuck they most admire
While you gnaw cold, hard biscuits 'cause the cook can't build a fire.
When you're ridin' on the cattle range and hit a rainy spell,
Your whiskers git plumb mossy and you note a mildewed smell
On everything from leather to the makin's in your sack;
And you git the chilly quivers from the water down your back.
You couldn't pull your boots off if you hitched 'em to a mule;
You think about them ribbon clerks, and call yourself a fool
For ever punchin' cattle with a horse between your knees,
Instead of sellin' ribbons and a-takin' of your ease.
You sure do get to ponderin' about them jobs in town,
Where slickers ain't a-drippin' when the rain comes sluicin' down.
It's misery in your gizzard, and you sure do aim to quit,
And take most any sheltered job you figger you can git.
But when you've got your neck all bowed to quit without a doubt,
The rain just beats you to it, and the sun comes bustin' out!
Your wet clothes start to steamin', and most everywhere you pass
You notice how that week of rain has livened up the grass.
That's how it is with cowboys when a rainy spell is hit:
They hang on till it's over—then there ain't no need to quit.

# Little Joe, The Wrangler

By Jack Thorp

Little Joe, the wrangler, will never wrangle more;
His days with the remuda—they are done.
'Twas a year ago last April he joined the outfit here,
A little Texas stray and all alone.

'Twas 'long late in the evening he rode up to the herd
On a little old brown pony he called Chaw;
With his brogan shoes and overalls a harder looking kid
You never in your life had seen before.

His saddle 'twas a southern kack built many years ago,
An O.K. spur on one foot idly hung,
While his hot roll in a cotton sack was loosely tied behind
And a canteen from the saddle horn he'd slung.

He said he'd had to leave his home, his daddy's married twice
And his new ma beat him every day or two;
So he saddled up old Chaw one night and "Lit a shuck" this way
Thought he'd try and paddle now his own canoe.

Said he'd try and do the best he could if we'd only give him work
Though he didn't know "straight" up about a cow,
So the boss he cut him out a mount and kinder put him on
For he sorter liked the little stray somehow.

Taught him how to herd the horses and to learn to know them all
To round 'up by daylight, if he could.
To follow the chuck wagon and to always hitch the team
And hep the "cosinero" rustle wood.

We'd driven to Red River and the weather had been fine;
We were camped down on the south side in a bend
When a norther commenced blowing and we doubled up our
    guards
For it took all hands to hold the cattle then.

Little Joe, the wrangler, was called out with the rest
And scarcely had the kid got to the herd
When the cattle they stampeded; like a hail storm, long they flew
And all of us were riding for the lead.

'Tween the streaks of lightning we could see a horse far out ahead
'Twas Little Joe, the wrangler, in the lead;
He was riding old blue Rocket with his slicker 'bove his head
Trying to check the leaders in their speed.

At last we got them milling and kinder quieted down
And the extra guard back to the camp did go
But one of them was missin' and we all knew at a glance
'Twas our little Texas stray, poor wrangler Joe.

Next morning just at sunup we found where Rocket fell
Down in a washout twenty feet below
Beneath his horse, mashed to a pulp, his horse had rung
    the knell,
For our little Texas stray—poor wrangler Joe.

# The Greatest Sport

By Georgie Sicking

An old Nevada mustang
As wild as she could be…
I'll tell you all for sure,
She made a gambler out of me.

I forgot I was a mother,
I forgot I was a wife.
I bet it all on the horse I rode;
On him, I bet my life.

The thrill of the chase with my roan
Horse trying to give me a throw,
The smells of the dust and the
Sagebrush, the rattle of rocks as we go.

Blood running hot with excitement,
Mouth getting dry from the same.
In this world, ain't nothin' but the mustang,
Roan horse, and me and the game.

Mustang is getting winded.
It slows down to a lope.
Roan horse is starting to weaken,
Mustang gets caught in my rope.

Roan horse's sides are a heavin'
And I am all out of breath.
Mustang faces rope a tremblin';
It would have run to its death.
Sanity returns and I'm lookin'

At the wild horse I just caught.
My prize of the chase,
Good-looking or pretty it is not.

A hammer head, crooked leg,
It's awful short on the hip.
Little pig eyes, a scrawny U-neck,
And it's really long on the lip.

No she ain't worth much,
For sure she ain't no pearl.
But she took me from a humdrum life
Right to the edge of the world.

Now, mustangin' is a fever,
Like alcohol, gamblin' and such.
I guess it don't really matter
If what you catch ain't worth that much.

This was before the laws were passed
That fed the city folk's dreams.
I was lucky to enjoy the sport
Of cowboys and of kings.

## Some Girls Are Worth Fighting For
By Karen G. Myers

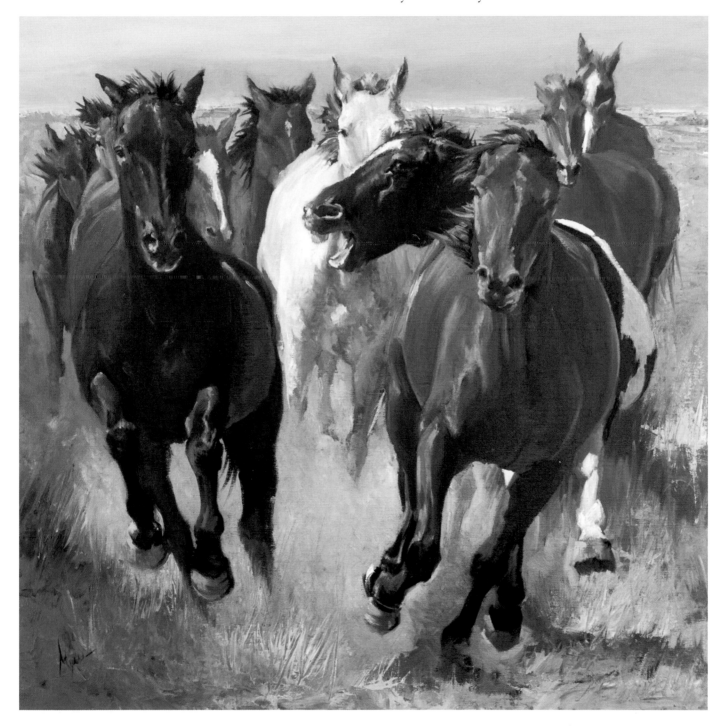

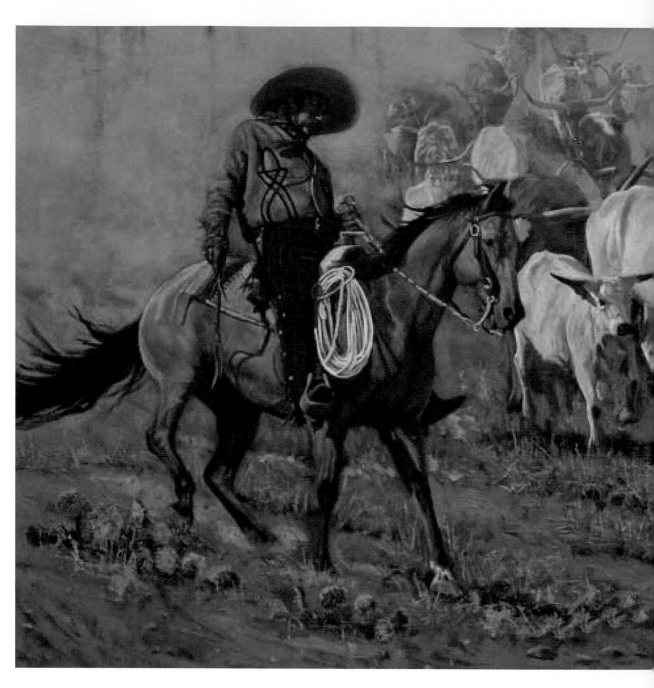

**The Drovers**
By John Phelps

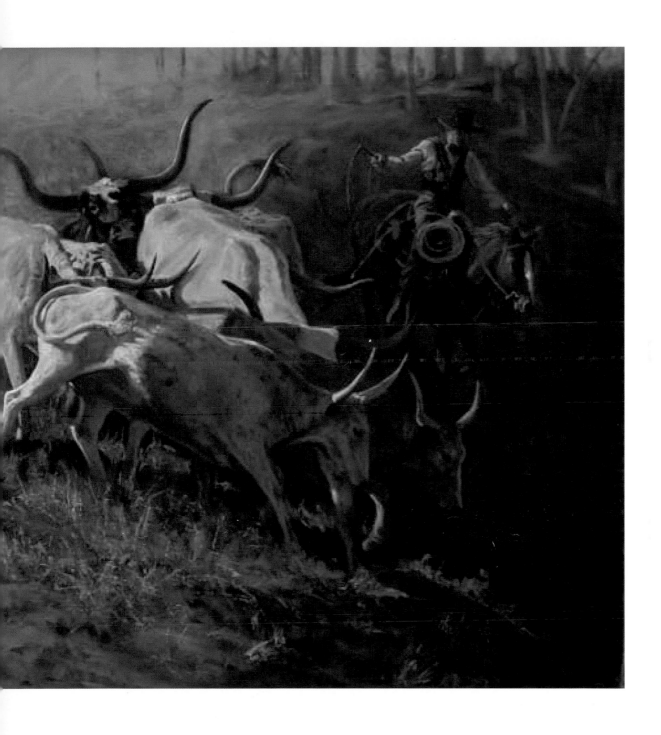

*John Phelps* was born and raised in Wyoming into
a life of cowboying and horse packing which lends
authenticity to his subjects. He still lives in Wyoming.
*(www.johnphelps.com)*

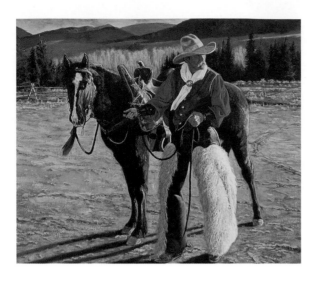

**Rocky Mountain Saturday Night**
By John Phelps

# Saturday Night at Swamp Creek

By Gwen Petersen

There's always a dance on Saturday
At Swamp Creek School House Hall;
The cowboys come from far and near
Like bulls when heifers bawl.

Slicked up and sharp in clean blue jeans
Shaved faces reek cologne,
Or beards close-trimmed, mustaches curled—
Makes cowgirls softly moan.

The cowboys park their rigs out back
Then head into the fray;
They make real sure their bottled brave
Is not too far away.

Now cowgirls laugh as they arrive
Wearing brand new duds,
Their jeans so tight they could be paint—
The sight inspires the studs.

The music starts with heavy beat,
Guitar, kazoo and drum;
The cowboys all are petrified,
Their dancing parts are numb.

The hours go by, the crowd gets loud,
And still the boys sit tight,
Except to slouch from hip to hip
And study bugs in flight.

The clustered girls across the room
Try flirting more and more;
The cowboys shuffle, paw and snort
But still don't cross the floor.

The trips outside for liquid charm
Are made at every chance,
As nervous cowpokes stiffen spines
To ask a lass to dance.

So watch out, gals, here comes the rush
Get set for Fred Astaire;
They'll dance a two-step, waltz or rock,
They'll whirl you through the air.

Their elbows flap, their arms pump oil,
They gallop down the floor;
And cowgirls cling, their feet leave earth
But they'll be back for more.

It's strange and odd, but I tell it true,
How cowboys 'fore they wed—
Will carry on until the dawn,
But get 'em hitched, they're dead.

# Our Boss

By Bruce Kiskaddon

He started young and he drifted far—
The owner out at the Diamond-Bar.
He has cattle grazing on many a hill,
But down in his heart he's a cow-boy still.

Though other owners put on airs,
It's little for style that our boss cares;
He wears his boots and his leather chaps,
And everybody calls him "Tap."

He bandies jokes and exchanges news,
As he rides the range with his buckaroos;
He sits his horse with a careless grace,
And rides at a stockman's jogging pace.

But the horses he rides all come of a breed
That are bred for mettle and built for speed.
The thing that he really most enjoys
Is a horse round-up with a bunch of boys.

It's then he rides at a pace that kills,
Through the open flats and the rugged hills;
With spurs set close and with flying reins—
Like he rode when a boy on the Texas plains.

Or else, when he jumps big mountain steers,
That have dodged the round-up for several years—
Down comes his rope, and away they dash,
While the hoof-beats ring and the cedars crash,
Till the bellowing steer on the mountain side,
Proclaims the fact that he's roped and tied.

I have seen him riding at racing speed—
Singing in front of a mad stampede—
As calmly as most old gentlemen do,
When sitting at church in a rented pew.

If he did retire and settle down
He would waste away in the sheltered town
Where he couldn't hear the cattle bawl,
The horses neigh, and the coyotes call
He was raised on the range, and there he stayed—
One of the boys of the old brigade.

## Canyon de Chelly
By William Matthews

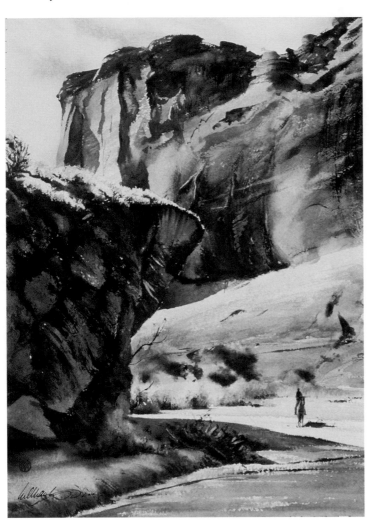

## Waddy Rehearses
By William Matthews

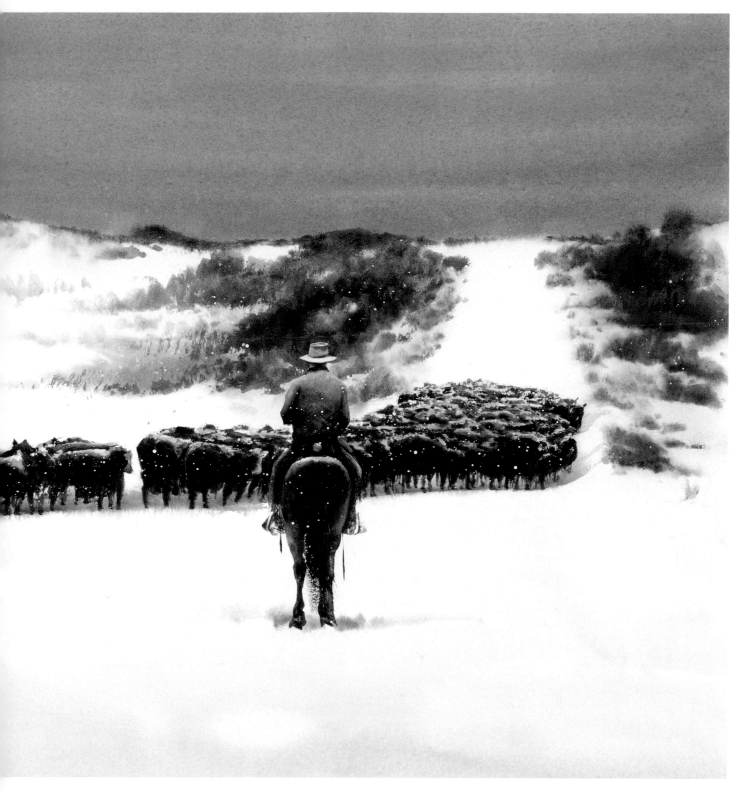

## Breaking Trail
By William Matthews

*William Matthews* has painted locations
around the world but always returns to his favorite
subject, the American West. He lives in Colorado.
(www.williammatthews.com)

# No Step for a Stepper

By Sue Wallis

Dad taught me how to swing a rope and
Step on colts
How to eat a slicker-full, cowboy style
Tomatoes, peaches canned and sardines
With a pocket knife
He taught me ways that cattle work
When to push and when to hold
And where to look
He taught me pride and built me strong and he
Tried to teach me
Life

When I jumped wrong, shied back when I shouldn't run—
Or didn't know
He was there with a hand for my shoulder

When the baby came, but the daddy didn't, I went home
Young and scared
Mama hugged me, held me hard and told him for me

I didn't know, but
Daddy looked at me, "What will you do?"
I said, "I'll keep it"
Dad said, "Good"
And put his hand on my shoulder

When the governor called and I became the Chair
    of the Board
Too young and scared, I didn't think I had it in me
But Daddy smiled, said, "Just start stepping"
Put his hand on my shoulder
And I knew I could

When I married wrong, but didn't know
He held his tongue, and stood by me
Delighted in his grandchildren
When the fourth one died unborn, but whole
He saved my soul, just looked at me
Smiled sad and slow
And put his hand on my shoulder

When Granddad died—the family's memories mine to say
The tribute for an honored man, deep-loved by man
I didn't know if I had it in me
Dad's hand on my shoulder, and his eyes of pride
Knew that I could
And so did I

To the very end when times are hard
When I don't know
I'll look within to find my dad
To see those eyes and feel that hand
And know I can

To the very end I'll always hear
Those Daddy words of his
As the challenge comes
When the road gets rough or disappears
When the tests are tough
With that hand on my shoulder
That flash of eye, that cocky grin
And those words from him—

"Hell it ain't no Step…for a Stepper"
And he shows the way
So I can set to Stepping

**A Lot Like Heaven**
By Tim Cox

# Cattle, Horses, Sky and Grass
By Sue Wallis

Cattle, horses, sky and grass—
these are the things that sway and pass
before our eyes and through our dreams,
through shiny, sparkly, golden gleams
within our psyche that find and know
the value of this special flow
that only gleams for those who bleed
their soul and heart and utter need
into the mighty, throbbing Earth
from which springs life and death and birth.
These cattle, horses, grass and sky
dance and dance and never die—
they circle through the realms of air
and ground and empty spaces where

a human being can join the song—
can circle, too, and not go wrong
amidst the natural, pulsing forces
of sky and grass and cows and horses.

This chant of Life cannot be heard,
it must be felt, there is no word
to sing that could express the true
significance of how we wind
through all these hoops of Earth and mind—
through horses, cattle, sky and grass
and all these things that sway and pass.

# Beef Eater

By Linda M. Hasselstrom

I have been eating beef hearts
all my life.
I split the smooth maroon shape
lengthwise,
open it like a diagram, chambers exposed.
I cut tough white membranes off valves,
slice onions over the heart,
float it in water,
boil it tender.
I chop prunes, apricots, mushrooms
to mix with dry bread,
sage from the hillside.
I pack the crevices full,
nail the heart together,
weave string around the nails.

Gently, I lift the full heart
between my hands,
place it in the pan
with its own blood, fat, juices.
I roast that heart
at three hundred fifty degrees

for an hour or two.
Often I dip pan juices,
pour them lovingly over the meat.
When I open the oven,
the heart throbs
in its own golden fat.

I thicken the gravy with flour,
place the heart with love
on my grandmother's ironstone platter,
slice it evenly from the small end;
pour gravy over it all,
smile as I carry it to the table.

My friends have begun to notice my placid air,
which they mistake for serenity.
Yesterday a man remarked on my large brown eyes,
my long eyelashes,
my easy walk.

I switched my tail at him
as if he were a fly,
paced
deliberately
away.

## Happy Hour
By Mary Ross Buchholz

## Branding Time
By Mary Ross Buchholz

*Mary Ross Buchholz is from a pioneer ranching family. She picks her subjects from her own family ranch in West Texas. (www.maryrossbuchholz.com)*

# The Road Most Often Taken

By Virginia Bennett

Given the choice, I'll always take
The trail toward the lofty ridges.
Where the winds brush the pines' long needles
And the timber rattlers hide.
Where it's colder, steeper, riskier,
And the path hugs granite ledges.
If it's up for grabs and I have the chance,
That's the place I choose to ride.

Along the canyon rim, where the coyote trots
As he hunts for his harried dinner.
Where I'm riding at eyeball level
With a hawk on a thermal glide.
If there's cows escapin' the flies and heat,
Or a bull loungin' like an unrepentant sinner,
If you need a cowboy to head up there…
Then, yessir, that's where I'll ride.

The views, unfenced and uncorralled,
Tempt the eye for a lingering gaze.
Where you're tricked into believin' you see it all,
And from them flatlanders, you stand apart.
And, there's something about just sharing the air,
Up there where the elk herds graze.
Guess you could say I'm a high ridge runner
Down deep in my simple heart.

# A Life

By Everett Ruess

A life
    Is a mirror
Reflecting the road over which it passes.
    Sometimes
When it rains
    The mirror itself is reflected in the road.

**Be Not Afraid**
By Teresa Jordan

# Death of a Loner

By Virginia Bennett

Gray tendril across a frozen cheek,
She was found on the trail to the woodpile.
Light dusting of snow blanketed her form
And hungry cats eyed her body from the window inside.
The heart, surviving innumerable hurts
And desertions and years of loneliness
Finally stopped when her head hit the ice
And the world went dark.

A well-oiled fiddle hangs on the wall of the empty cabin,
Once played softly for an audience of one (the player).
Old cows, with no loving hand to feed them,
Strained against the fence
To glean wisps of hand-mown, mountain hay.
A woman, outcast from her sisterhood,
Lay in the aching stillness of the land.
After fifty-three years of living alone,
No one had missed her these last two weeks.

**Opuntia**
By Karen G. Myers

# The Cowboy's Soliloquy

By Allen McCandless

All day o'er the prairie alone I ride,
Not even a dog to run by my side,
My fire I kindle with chips gathered round,
And boil my coffee without being ground.

Bread lacking leaven I bake in a pot,
And sleep on the ground for want of a cot.
I wash in a puddle and wipe on a sack,
And carry my wardrobe all on my back.

My ceiling the sky, my carpet the grass,
My music the lowing of herds as they pass,
My books are the brooks, my sermons the stones,
My parson's a wolf on a pulpit of bones.

But then if my cooking ain't very complete,
Hygienists can't blame me for living to eat;
And where is the man who sleeps more profound
Than the cowboy who stretches himself on the ground.

My books teach me constancy ever to prize,
My sermons that small things I should not despise;
And my parson's remarks from his pulpit of bone,
Is that "the Lord favors those who look out for their own."

Between love and me lies a gulf very wide,
And a luckier fellow may call her his bride;
But Cupid is always a friend to the bold,
And the rest of his arrows are pointed with gold.

# Ode To My Lady, My Wife

By Sunny Hancock

I had all my Christmas shopping done,
all that I had to do,
All that I had left to get this year
was one small gift for you;
The sort of thing I find
with which is very simple dealt
A gift which would explain to you
exactly how I felt.

Then my mind began to wander
as my mind will sometimes do,
Running back along the days and times
and years I've spent with you.
And as I got to thinking
of those cherished yesterdays,
It dawned on me that we've been
down the road quite a ways.

We've worked some tacky ranches
and we lived in weathered shacks
Where the wind would blow the lamp
     out
when it whistled through the cracks.
You'd take care of me and both the kids,
and hold a job in town,
And still have time to smile
and spread a lot of love around.

If I'd come home disgusted,
grumbling 'bout the job I had
Just a little time with you
and then things wouldn't look so bad.
Then later when we'd bought the ranch
and you cooked at the school,
I was workin' in the woods
all day so usually as a rule

You'd have to do the feedin'
chop the ice, and, if you could,
Milk the cow and feed the leppies
and then sometimes split some wood.
And I'd get home way after dark
from puttin' in my hours;
I'd find that you'd just pulled a calf
or maybe doctored one with scours.

You never did complain much,
always had a lot of heart;
Only maybe just to mention
that the tractor wouldn't start.
Then when school was out for summer
golly what a happy day.
You would spend it changing hand line,
floodin', workin' in the hay.

Should have had three men
to help with all the work you had to do.
I'd be there afternoons and weekends
and somehow we made it through
And now when you look in the mirror
at the lady standing there,
Why, there's some wrinkles in her
     forehead,
and some silver in her hair.

She's maybe packin'
just a little bit of extra weight
And you don't like what you see there
but to me she sure looks great.
So while we're lookin' at that image,
why, we maybe won't agree,
But here's what that reflection
standin' up there means to me.

She's my Wife and she's my Partner,
she's my Mate and she's my Friend,
She's the Mother of my children,
she's my Lover, then again
My Companion on life's highway;
she'll light up the blackest night.
Life seems just a wee bit better
any time that she's in sight.

She's my Teacher an' she's taught me
that life really can be fun.
Don't you worry 'bout a few gray hairs
you've earned 'em every one.
Now far as Christmas shoppin',
guess I didn't do so good,
Bought you something pretty common
like you might have known I would.

Since your present ain't so special
and it ain't too big a deal,
I thought I'd write this note to you
and tell you how I feel.
If God would grant a wish for me
(I'm sure just one would do),
I'd simply wish that I could spend
a lot more years with you.

Your loving Husband

**Three-Fingered Jack**
By Tom Browning

## Horse Talk
By Tom Browning

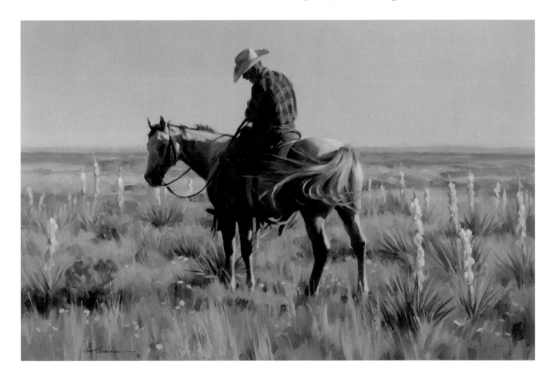

*Tom Browning,* born in Oregon, has been painting
professionally for forty years. In 2009, he was invited to
join the prestigious Cowboy Artists of America. He lives
in Arizona. (www.tombrowning.com)

# Scotty

By Joel Nelson

The flaxen maned colt
That had more cow than any
Three horses I ever rode
Scotty who I named after
Peter Scott—the Aussie—a good horse hand
Who worked for me
Scotty—who after a long morning circle
And roping two calves
Tied to lead in later
Bucked me off
In the noon camp cook fire.
Scotty who never quite got plumb broke
In seven years of dragging calves
And working herds
Was still the closest to perfect
That I ever rode.
The "buck fever" that never hit
In thirty some-odd years of dropping venison
That never hit even before or after my first deer
Dropped from one well-placed .30-30 silvertip
Hit me now—turning my knees to jelly
Bringing the nausea
Hit me just after the colt revolver
Bucked in my hand
And Scotty dropped in front of me
Hit me as if that first .30-30 slug
Had come full circle
On a thirty some-odd year journey
And plugged me dead center!

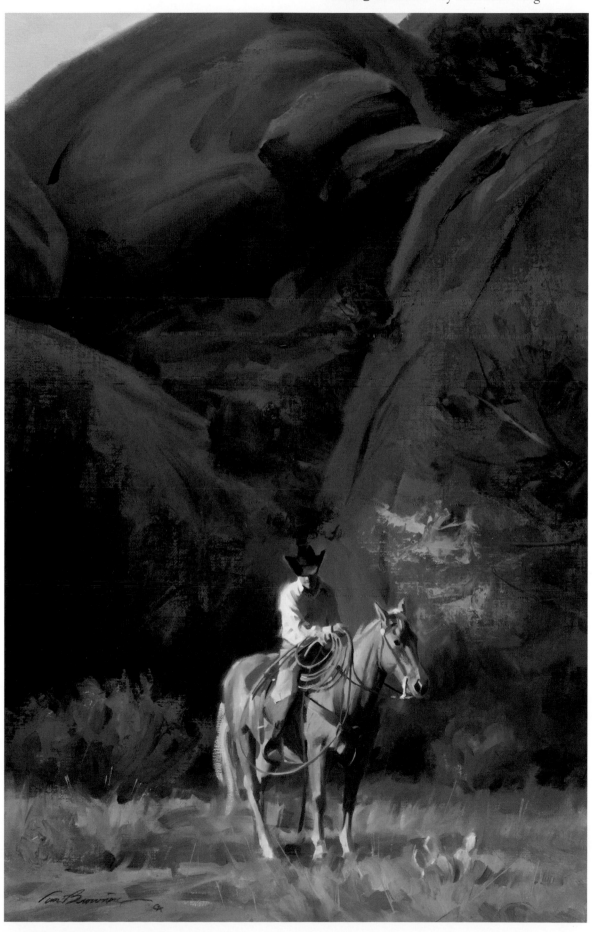

# His Horses

## By Laurie Wagner Buyer

I do not dream of him or the way he once held me,
I dream of him and his horses—

their names sliding through fingers of consciousness
like butter-soft reins on a worn-out summer day—

Peanuts, Diamond, Blackie, Buck, Duchess, Claude,
Tequila, Bill, Honda, Shavano, Honeybee, Ned…

He swings a saddle, settles it on a humped-up back,
vapor puffs from flared nostrils as he reaches for the cinch.

He sticks a spurred boot into a stirrup and is gone,
riding into another sunrise to chase down a herd of chores.

Slats, Socks, Smoke, Booger Red, Blue, Billy Bars,
Rastus, Poco, Wink, Jake, Keno, Dancer…

He heaves on a harness, the hames high over his head,
a velvet nose buried in the grain box as he adjusts
    the britchin'.

Not easy to hold them in and keep their heads up, his hands
slip on thick four-up lines stiff with twenty-below cold—

Pat and Mike, Stubby and Dick, Nell and Bell,
    Tom and Molly,
Donnie and Clyde, Jack and Jill, Hoss and Boss…

He counts wrecks the way some people count birthdays,
each one a reminder that it's a miracle he's still alive.

I do not think of him and the way he once loved me.
I think of him and his horses—

Their names echoing over the winter meadows
    as he stands
pitchfork in hand near the pole corral calling at dawn:

Amigo, Dunny, Brandy…Cookie…Candy.

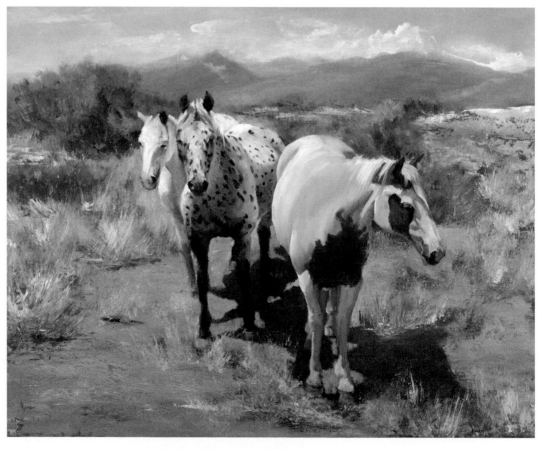

**Medano Zapata Threesome**  By Karen G. Myers

# Your Silence Will Not Protect You

By William E. Black Jr.

Each day the world you saw
Bloom and grow has withered;
Your hopes vanquished
In a heat of indifference
And inaction of fear,
In unechoing silence.
There was nothing to hear.

What you never said or did haunts you.
In your pain, you learn
   Your silence will not protect you.

Each day, your freedoms are taken away
By those who stridently choose to oppress you.
Each day, a little freedom is chipped from you
Because you do not show that it matters
And chains for your enslavement grow
Because you did not speak, did not oppose
Those who would enslave you.

What you never said or did haunts you.
In your pain, you learn
   Your silence will not protect you.

You study histories written by the victors
And see the disregard they show
To those who do not speak for others,
To those who did not speak for themselves,
To those who did not show opposition
To oppression and loss of freedom.
To those who chose safe silence before liberty.

What they never said or did haunts you.
In their pain, you learn
   Your silence will not protect you.

How long will you wait? How long will you
   let it go?
Your survival and happiness are at stake,
Your choices for a different tomorrow.
You must see that silence is loss
And even an unsteady and uncertain voice
Can start to change tomorrow,
And change the cycle in which

What you never say or do will haunt you.
In your pain, you will continue to learn
   Your silence will not protect you.

# Obstacles
By John Dofflemyer

There are boulders even
in dry creek beds, obstacles
for water to flow around—make
the sounds that soothe us so.

Easily identified, some are bolted down
like the mountains with sharpened edges
eerily singing new refrains each night.
We know them. Sometimes we curse them.

We even pray to God to remove them
from our channeled way of going, yet
not believing the music we cherish most
comes from rubbing against them.

# Old Men
By John Dofflemyer

So much needs not to be said.
Old men grin with their eyes,
save breath with a look

of understanding, yet
the preachers, teachers and poets
go on and on, searching

for resonance, for the magic
words to open doors, when
all we need to do is look.

**Solitude**
By David Graham

# Calving Fields
By John Dofflemyer

Blond on black,

a filigree of empty shells on long stems bent
to new life trembling in a breeze, the light
and hollow grace of late spring rains, these

wild oats arched, these sun-bleached skeletons
that remain, concealing the first throbs of heart
driven by instinct apart from the cowherd.

Sometimes we cannot see, cannot find
what she has hidden, despite curious coyote
pups skulking in the shade, ravens in trees.

Sometimes we miss the miracle of cycles,
the circles of rain—think each day the same.
These old hills come alive, inhale in long

shadows of oaks shedding leaves and acorns.
The invitations have been sent, bulk mail
on gusts to everyone, but only the wild respond.

## Emerson Cliffs
By Sophie Sheppard

**Sophie Sheppard** *is a third-generation Great Basin painter and writer who lives on a California ranch in Surprise Valley. Known for her large realist watercolors, she has recently started painting what she calls nonfiction—oil plein air paintings.*

*"I have been totally seduced by the beauty that surrounds us here," she says. Daughter of well-known Nevada artists, Craig and Yolande Sheppard, and granddaughter of the painter, Oscar Brousse Jacobson, she follows family tradition in Lake City.*

# In the Evening Autumn
By Linda Hussa

As I rode out to check the cows calving
the light came across the meadow low
soft
and in it
I could see a shimmering of cobwebs
moving in the breeze
like the surface of water.

The whole of the meadow
under billowing silk.

While I go about my singular life
an army
of small spiders
has set about to hold this entire world together
in a veil of fine silver strands.

# The Disputed Epicure

By Wally McRae

"What's your favorite cut of beef?"
    the highborn lady queried,
Of an old cowboy who long ago
    had grown both wise and wearied,
Of direct infernal questions
    on the ways of cowpoke lore.
So he considered on this question
    that he'd not been asked before.

With rapt anticipation
    on his pause, the lady hung.
Until, at last the cowboy said,
    "I'd have to say it's tongue.
Tongue's got flavor 'n texture,
    and nary a bit of bone.
A cinch to cook. I'd put her up
    on top there all alone."

Recoiling, the lady said aghast,
    "Surely sire, you jest.
The idea is disgusting.
    Your grossness I protest.
Eat something from out a cow's mouth?
    Your suggestion's crude, I beg."
The cowboy then said softly,
    "Don't s'pose you've ate no egg."

**Skeptic**
By Teresa Jordan

**Arizona Romance**
By Buckeye Blake

# That Letter

By Bruce Kiskaddon

I rode to that box a settin' on a post beside the trail,
That our outfit used fur gettin' all their messages and mail.
There I got a little letter and the envelope was pink.
It shore set me feelin' better but it soter made me think.
Yes the feelin' was surprisin' onderneath my stetson hat.
I could feel my hair a risin' like the bristles of a cat.

Well I tore that letter open and I read it through and through.
All the time I was a hopin' I would savvy what to do.
Men is quick upon the trigger, come to tangle ups and fights,
But a woman, you cain't figger what she means by what she writes.
It was purty and invitin' like a sunny day in spring,
She had done a heap of writin' but she hadn't said a thing.

Now, when men folks start to writin' you can mostly onderstand,
And the stuff that thay're a sightin' stands out plain jest like a brand.
They don't never do no playin', they've a sort of sudden way.
For they start right in by sayin' what they started out to say.
Men is given to expressin' what they mean, right then and there,
But a woman keeps you guess'n till your mind goes everywhere.

Fer a spell I'd do some thinkin' then I'd start again and read;
I kept frownin' and a blinkin' till at last I got her lead.
In that letter there was lurkin' jest one simple plain idee.
When I got my mind a workin' it was plain enough to see.
Fer she said her and her mother, come a Saturday next week
Would be over with her brother to the dance on Turkey Creek.

On the start, you see, I never had no notion what she meant,
She had fixed it up right clever in the way the letter went.
Man! I shore did whoop and beller when the idee hit me fair,
She would come without no feller and she aimed to meet me there.
It shore made me like her better fer that bashful gal of mine,
Went and built that whole durned letter, jest to write that single line.

# The Horse Trade

By Sunny Hancock

I traded for a horse one time,
  he wouldn't take no beauty prize;
A great big long-eared, blue roan gelding,
  not too bad for weight or size.
I had to make some tough old circles
  and this trade guaranteed
This horse would show me lots of country
  and not need too much rest or feed.

He said, "Now this here ain't no kids' horse
  but he'll pack you up the crick,
He will hump up on some occasions
  and he has been known to kick.
I wouldn't trade him to just anyone
  without having some remorse
But if you're a sure enough cow puncher,
  Mister, he's your kind of horse."

I stepped on that horse next mornin';
  he began to buck and bawl.
That trader maybe hadn't lied none,
  but he hadn't told it all.
Because we sure tore up the country
  where he throwed that equine fit
And I almost ran out of hand holds
  by the time he finally quit.

I guess that musta' set the pattern;
  things just never seemed to change,
Although I showed him lots of country,
  every corner of the range.
But every time I'd ride that booger,
  why, he'd keep me sittin' tight.
I knew I'd make at least three bronc rides
  'fore he'd pack me home that night.

Which woulda' been okay
  with lots of horses that I knowed
But that old pony had my number;
  I'd just barely get him rode.
And the thing that really spooked me
  and put a damper on my pride
Was he was learning how to buck
  faster'n I was learnin' how to ride.

I pulled into camp one evening;
  it was gettin' pretty late.

I see this gray horse in the corral
  and there's a saddle by the gate.
I looked that gray horse over
  and I sure liked what I seen,
Then this kid showed up around the barn;
  he musta' been 'bout sixteen.

He said he'd lamed the gray that morning
  coming down off granite grade,
And he wondered if I had a horse
  I'd maybe like to trade.
He said he didn't have the time to stop
  and rest and let him heal,
And since that beggars can't be choosers,
  he'd make most any kind of deal.

When a feller's tradin' horses,
  why, most anything is fair,
So I traded him that blue roan
  for his gray horse then and there.
But then my conscience started hurtin'
  when I thought of what I did,
To trade a "fly blown" dink like that
  off to some little wet-nosed kid.

So next mornin' after breakfast,
  why, I tells him, "Listen, lad,
If you want to know the truth,
  that trade you made last night was bad.
That old blue horse is a tough one,
  bad as any one you'll see.
He'll kick you, strike you, and stampede,
  he's a sorry SOB.

"It's all I can do to ride him
  and I'll tell it to you straight,
I think you'll be awfully lucky
  just to ride him past the gate.
There's two or three old horses
  out there in the saddle bunch.
They ain't got too much going for 'em
  but I kinda got a hunch

"They'll prob'ly get you where you're
  going
  if you just don't crowd 'em none,
But, damn, I hate to see you ride
  that blue roan booger, son!"
He said, "I told you there last night
  I'd make most any kind of trade,
And I appreciate your tellin'
  what a bad mistake I made.

"But my old daddy told me when you're
  tradin'
  that no matter how you feel,
Even if you take a whippin'
  that a deal is still a deal.
That horse, you say has lots of travel,
  and he's not too bad for speed.
Well, sir, I'm kinda in a tight
  and that's exactly what I need.

"I traded for him fair and square
  and damn his blue roan hide,
When I pull out'a here this morning,
  that's the horse I'm gonna ride."
I watched him cinching up his saddle
  and he pulled his hat way down,
Stepped right up into the riggin'
  like he's headed straight for town.

Stuck both spurs up in his shoulders,
  got the blue roan hair a-flyin'
Tipped his head straight back and
  screamed
  just like a hungry mountain lion.
You know, I've heard a lot of stories
  'bout the bucking horse ballet.
I've heard of poetry in motion,
  but the ride I saw that day

Just plumb complete defied description
  though I still can see it plain,
Like it had happened in slow motion
  and was branded on my brain.
I don't suppose I could explain it
  to you even if I tried.
The only thing that I can say is,
  by the saints, that kid could ride.

He sat there plumb relaxed
  like he was laying home in bed,
And every jump that pony made,
  that kid's a half a jump ahead.
When it was over I decided
  I could learn a few things still,
And I said, "Son, I'm awfully sorry
  I misjudged your ridin' skill."

He just said "Shucks that's OK, mister,"
  as he started on his way,
"But if you think this horse can buck,
  don't put your saddle on that gray."

**Getting High** By Bill Owen

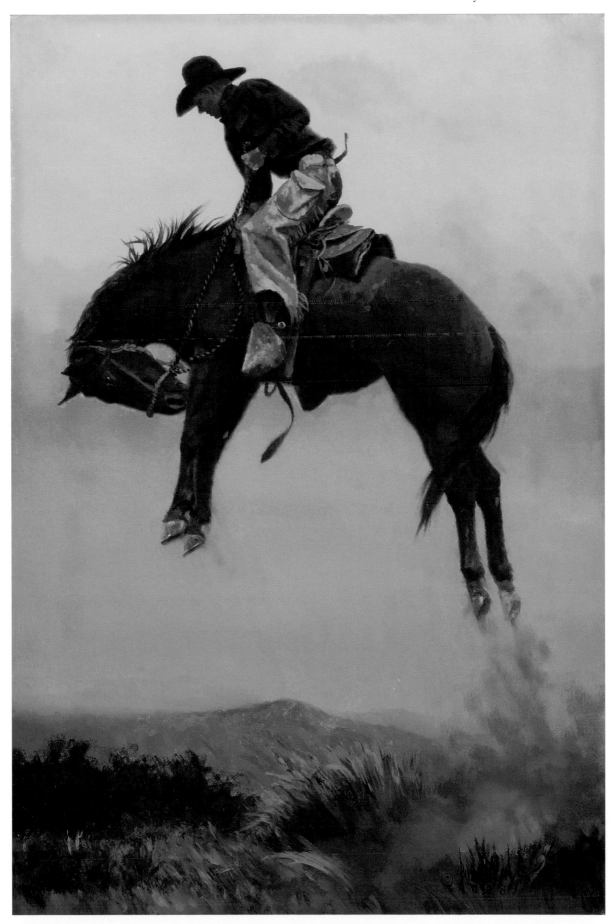

89

# In the Droving Days

By Banjo Paterson

"Only a pound," said the auctioneer,
"Only a pound; and I'm standing here
Selling this animal, gain or loss—
Only a pound for the drover's horse?
One of the sort that was ne'er afraid,
One of the boys of the Old Brigade;
Thoroughly honest and game, I'll swear,
Only a little the worse for wear,
Plenty as bad to be seen in town,
Give me a bid and I'll knock him down;
Sold as he stands, and without recourse,
Give me a bid for the drover's horse."

Loitering there in an aimless way
Somehow I noticed the poor old grey,
Weary and battered and screwed, of course;
Yet when I noticed the old grey horse,
The rough bush saddle, and single rein
Of the bridle laid on his tangled mane,
Straightway the crowd and the auctioneer
Seemed on a sudden to disappear,
Melted away in a kind of haze—
For my heart went back to the droving days.

Back to the road, and I crossed again
Over the miles of the saltbush plain—
The shining plain that is said to be
The dried-up bed of an inland sea.
Where the air so dry and so clear and bright
Refracts the sun with a wondrous light,
And out in the dim horizon makes
The deep blue gleam of the phantom lakes

At dawn of day we would feel the breeze
That stirred the boughs of the sleeping trees,
And brought a breath of the fragrance rare
That comes and goes in that scented air;
For the trees and grass and the shrubs contain
A dry sweet scent on the saltbush plain.
For those that love it and understand
The saltbush plain is a wonderland,
A wondrous country, where Nature's ways
Were revealed to me in the droving days.

We saw the fleet wild horses pass,
And the kangaroos through the Mitchell grass;
The emu ran with her frightened brood
All unmolested and unpursued.
But there rose a shout and a wild hubbub
When the dingo raced for his native scrub,
And he paid right dear for his stolen meals
With the drovers' dogs at his wretched heels.
For we ran him down at a rattling pace,
While the pack-horse joined in the stirring chase.
And a wild halloo at the kill we'd raise—
We were light of heart in the droving days.

'Twas a drover's horse, and my hand again
Made a move to close on a fancied rein.
For I felt the swing and the easy stride
Of the grand old horse that I used to ride.
In drought or plenty, in good or ill,
The same old steed was my comrade still;
The old grey horse with his honest ways
Was a mate to me in the droving days.

*This poem ran in "The Bulletin," June 20, 1891.*
*It was also included in "The Man From Snowy River and Other Verses," October 2, 1895.*

**Five Cowboys**
By Craig Sheppard

When we kept our watch in the cold and damp,
If the cattle broke from the sleeping camp,
Over the flats and across the plain,
With my head bent down on his waving mane,
Through the boughs above and the stumps below,
On the darkest night I could let him go
At a racing speed; he would choose his course,
And my life was safe with the old grey horse.
But man and horse had a favourite job,
When an outlaw broke from a station mob;
With a right good will was the stockwhip plied,
As the old horse raced at the straggler's side,
And the green-hide whip such a weal would raise—
We could use the whip in the droving days.

"Only a pound!" and was this the end—
Only a pound for the drover's friend.
The drover's friend that has seen his day,
And now was worthless and cast away
With a broken knee and a broken heart
To be flogged and starved in a hawker's cart.
Well, I made a bid for a sense of shame
And the memories dear of the good old game.
"Thank you? Guinea! And cheap at that!
Against you there in the curly hat!
Only a guinea, and one more chance,
Down he goes if there's no advance,
Third, and last time, One! Two! Three!"
And the old grey horse was knocked down to me.

And now he's wandering, fat and sleek,
On the lucerne flats by the Homestead Creek;
I dare not ride him for fear he'd fall,
But he does a journey to beat them all,
For though he scarcely a trot can raise,
He can take me back to the droving days.

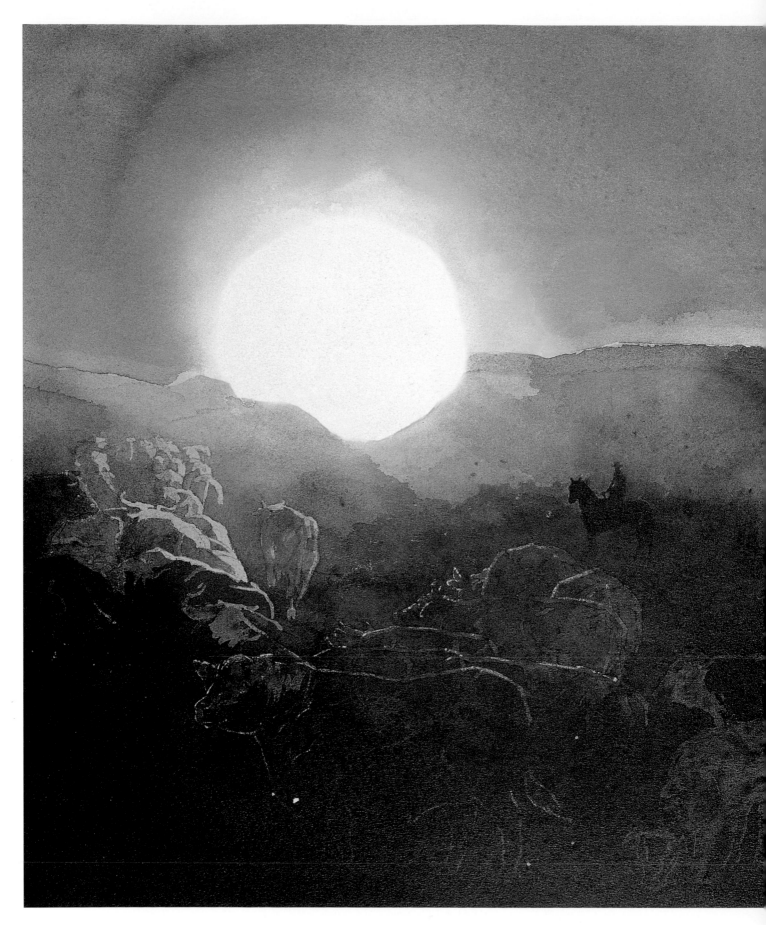

**Steven Saylor** *moved west to paint and ended up a cowboy for five years.*
*His highly detailed watercolors can take months to complete. His Nevada*
*studio is in an antique railroad car. (www.evergreenstudio.com)*

**Burnin' Daylight**
By Steven Saylor

# A Dream
By Hank Real Bird

With ancient songs kept in time by a rawhide rattle,
I sang songs of my people. The moon was bright
But I wouldn't let her in, and in the total darkness
The song's spirit lifted me onto a plain where beautiful
Feelings were gently exposed in my tears.
I know only the joy of life tonight
May you enjoy love in life
With the wind I sing
To send a feeling
That'll dwell in your heart
From the wind I sing
That you breathe within
A beautiful feeling in a gentle smile
Will come to light your soul.
The art of loving may you know.
In a dream I saw the green grass appear
As a faint shadow of green upon the hills
Where a white buffalo bull calf
Was bucking, and running around to test
His new legs, as his mother chased after him.
That was the beautiful sun shining day
I saw in tomorrow of a couple of moons away,
So may you be covered with love
For many winters to come.

# Equus Caballus

By Joel Nelson

I have run on middle fingernail through Eolithic morning,
I have thundered down the coach road with the Revolution's warning.
I have carried countless errant knights who never found the grail.
I have strained before the caissons, I have moved the nation's mail.
I've made knights of lowly tribesmen and kings from ranks of peons
I have given pride and arrogance to riding men for eons.
I have grazed among the lodges and the tepees and the yurts.
I have felt the sting of driving whips, lashes, spurs and quirts.
I am roguish—I am flighty—I am inbred—I am lowly.
I'm a nightmare—I am wild—I am the horse.
I am gallant and exalted—I am stately—I am noble.
I'm impressive—I am grand—I am the horse.
I have suffered gross indignities from users and from winners,
And I've felt the hand of kindness from the losers and the sinners.
I have given for the cruel hand and given for the kind.
Heaved a sigh at Appomattox when surrender had been signed.
I can be as tough as hardened steel—as fragile as a flower.
I know not my endurance and I know not my own power.
I have died with heart exploded 'neath the cheering in the stands—
Calmly stood beneath the hanging noose of vigilante bands.
I have traveled under conqueror and underneath the beaten.
I have never chosen sides—I am the horse.
The world is but a player's stage—my roles have numbered many.
Under blue or under gray—I am the horse.
So I'll run on middle fingernail until the curtain closes,
And I will win your triple crowns and I will wear your roses.
Toward you who took my freedom I've no malice or remorse.
I'll endure—This Is My Year—I am the Horse!

*Written in the autumn of the Year of the Horse 2002.*

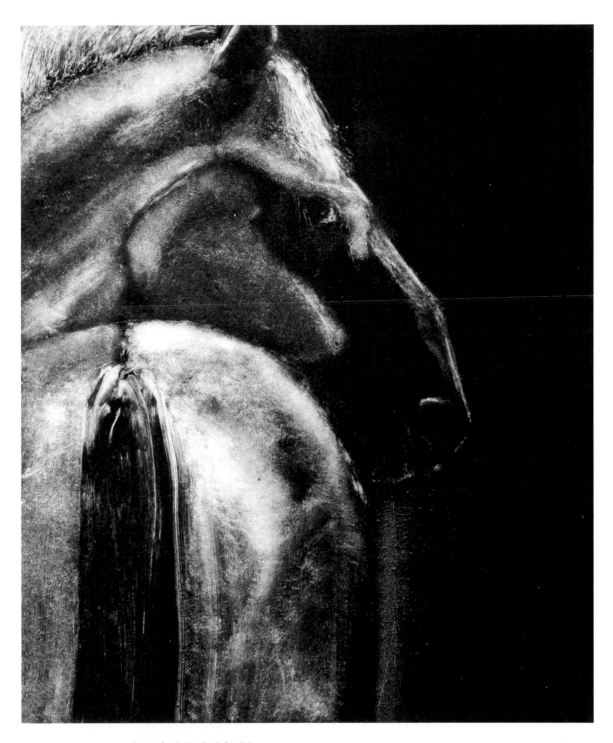

### Leaving Us Behind I
By Teresa Jordan

**Teresa Jordan** was raised as part of the fourth generation on a cattle ranch in the Iron Mountain country of southeast Wyoming. She has written or edited seven books about western life, including the memoir "Riding the White Horse Home." She has received the Western Heritage Award from the Cowboy Hall of Fame for scriptwriting and a literary fellowship from the National Endowment of the Arts. She is represented by Phillips Gallery in Salt Lake City, Utah. (www.teresajordan.com)

# Kindred Spirits

By J.B. Allen

The spotted heifer missed the drive, and spent the winter free.
Tho' freedom's price was willow bark, then sprigs of fillaree,
That finally showed beneath the snow, before her strength played out,
And green-up brought a fine bull calf, to teach the maverick route.

She fattened on the meadow of the High Sierra's flanks,
In comp'ny of a maverick bull that drifted from the ranks
Of cattle 'cross the Great Divide, turned loose to make their way
And lost amongst the canyons that were strewn in disarray.

The offspring of the union proved a wily beast, indeed.
Endowed with instincts from the wild and blessed with wondrous speed
That proved a worthy challenge to punchers in the hills
Who, thru the years spun hairy tales of wildest wrecks and spills.

But tho' the issue, from the two, was sometimes trapped or caught
These two ol' wily veterans still practiced what they taught
And spent each winter runnin' free within their secret haunt
Which held enough to see 'em through, emergin' weak and gaunt.

For years, Ol' Utah searched the range in futile quest for sign
Of where they spent the winter months and somehow git a line
On how they made it ever' year and brought a calf to boot
Till finally one cold winter day, it fell to this old coot
To happen on their winter park, hid out from pryin' eyes
And to this day, Ol' Utah holds the key to where it lies.

The kindred spirit shared by all who seek the higher range
Could not betray the cul de sac to folks just bent on change,
With no respect for maverick ways, or independent thought
And not one frazzlin' idee of the havoc bein' wrought
By putting things on schedule, be it work or man or cow,
Till ways that make for bein' free are plumb bred out, somehow.

So Utah turned and trotted off, to let them ol' hides be,
His heart a-beatin' lighter, just a-knowin' they were free.

# Spring Works Sonnet

By Rod Miller

Scrub oak tangles on the slopes; only
spots and specks of sunshine sneak in
where the calf lies silent and lonely.
Breaking branches become a buckskin

horse with limb-fending cowboy aboard.
Whistles and shouts, instinct and insecurity
bring the calf to its feet, drive it toward
the branding fire, burning hair and blistery

hide. Bawling calves mother up, sucking
away the taste of smoke. Sated, they drift
from dusty chaos with the drive, bucking
and running upslope to oak leaves that sift

golden shadows from low sun at end of day
as the dun horse carries the cowboy away.

**Number 470**

By Ann Hanson

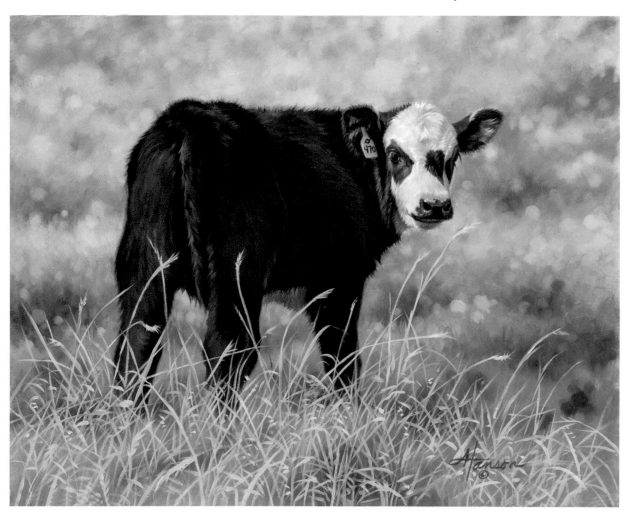

# Breaker in the Pen

By Joel Nelson

There's a thousand year old story
involving beasts and men.
With one of each we set the stage
and let the play begin.

Take Eohippus' grandson
now on middle fingernail,
and the world's most recent primate
with no vestige left of tail.

The first outweighs the second
eight times or maybe ten.
Nothing new this story of the horse
and the breaker in the pen.

At times he thinks he's crazy
other times he knows for sure
but centaur blood pumps through his
veins and there isn't any cure.

There are broncs that try his patience,
and those that test his skill.
Make him lie awake in nighttime,
make him almost lose his will.

There are stiffened, aching mornings
when he questions if he'll last,
'cause the breaker's close to fifty
while the broncs are still two-past.

No imaginary spider web
connects him to the brute,
just developed understanding,
maybe years in taking root.

A dozen broncs stand shivering,
the mist is rollin' in,
there's a slicker on the top rail
and a breaker in the pen.

He's a study in persistence,
even stubborn if you will—
can bend more often than he breaks
and tough, damn tough to kill.

Rumor runs he nursed on mare's milk,
some say he's into Zen;
truth is he lives and breathes the work,
the breaker in the pen.

There are times he feels restricted
by the endless little rounds,
wishing he were on the cow crew
with the roundup sights and sounds.

But he's seen the cattle sorted
now the crew comes trotting in
astride the horses started
by the breaker in the pen.

He's not high on riding buckers
and disdains the use of quirt;
He's eaten quite a little more
than his fair share of dirt.

So he reads what's there before him,
trying hard to catch the signs;
instinct or intuition
gives him what's between the lines.

This psycho-cybernetic work
has often saved his hide,
but the moment comes with every horse
when he has to mount and ride.

So fearless (or in spite of fear)
he moves to step astraddle
now what will be, will surely be,
for the breaker's in the saddle.

Here we redefine commitment,
for it's now the horse's deal;
the breaker's foot is shoved
into the stirrup to the heel.

The ride might end with two as one,
just like it all began,
else the breaker finds the wherewithal
to rise and ride again.

## When Horse Whispering Gets Loud
By Tim Cox

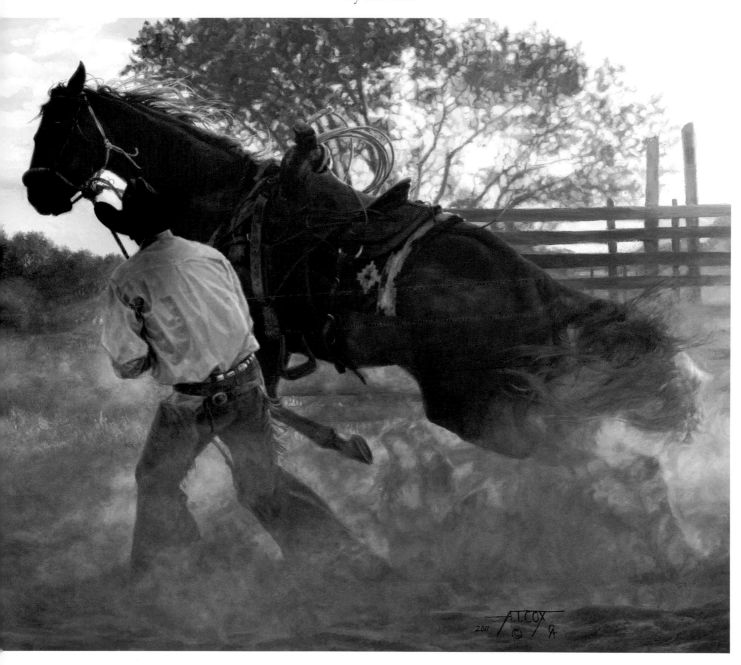

With triple-digit temperatures,
it's tough to hang and rattle,
the breaker's butt is heatsore
and bleeding in the saddle.

Hail the horses of the nations,
hear the stories of them told,
how they've carried kingdoms' armies,
how they've won Olympic Gold.

Carried Washington and Paul Revere,
helped set our country free,
carried Roosevelt and Houston,
John Wayne, and Grant, and Lee.

One thing they have in common,
their stories all begin
with one you seldom hear about—
the breaker in the pen.

**Silk Scarf**
By Mollie Erkenbrack

*Mollie Erkenbrack is a native Texan who was a designer and illustrator before pursuing a full-time painting career. (www.mollieerkenbrack.com)*

# Why Girls Love Horses
By Katie Andraski

1
The stallion grows out of my arm.
About to cover a mare, he suckles the wind.

2
The filly breathes close to me.
I breathe in tune with her
and become quiet to let her learn
the scent of sunlight in grass.

When a stallion swallows her,
she'll stand like a church in rain.
She'll grunt under his weight,
a torrent of legs pouring down her side.

# Turquoise

By Patty Barnhart

When I am an old horsewoman
I shall wear turquoise and diamonds,
And a straw hat that doesn't suit me.
And I shall spend my social security on white wine and carrots,
And sit in the alleyway of my barn
And listen to my horses breathe.
I will sneak out in the middle of a summer night
And ride the old gelding
Across the moonstruck meadow
If my old bones will allow.
And when people come to call, I will smile and nod
As I walk past the gardens to the barn,
And show instead the flowers growing
Inside the stalls fresh-lined with straw.
I will shovel and sweat and wear hay in my hair as if it were a jewel.
And I will be an embarrassment to all
Who will not yet have found the peace in being free
To have a horse as a best friend,
A friend who waits at midnight hour
With muzzle and nicker and patient eyes
For the kind of woman I will be
When I am old.

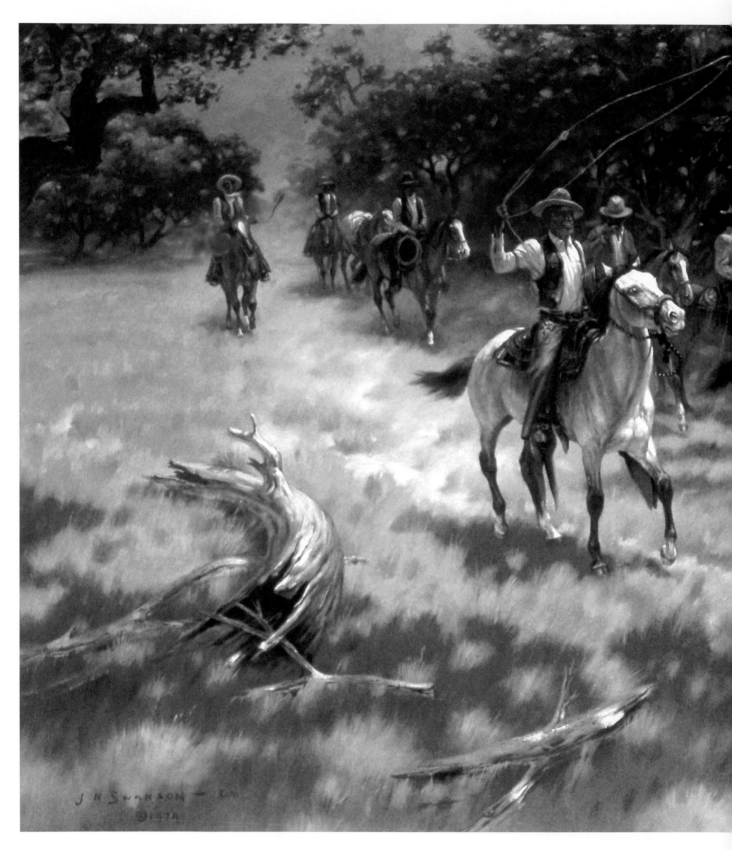

**The Last Roundup**
By J.N. Swanson

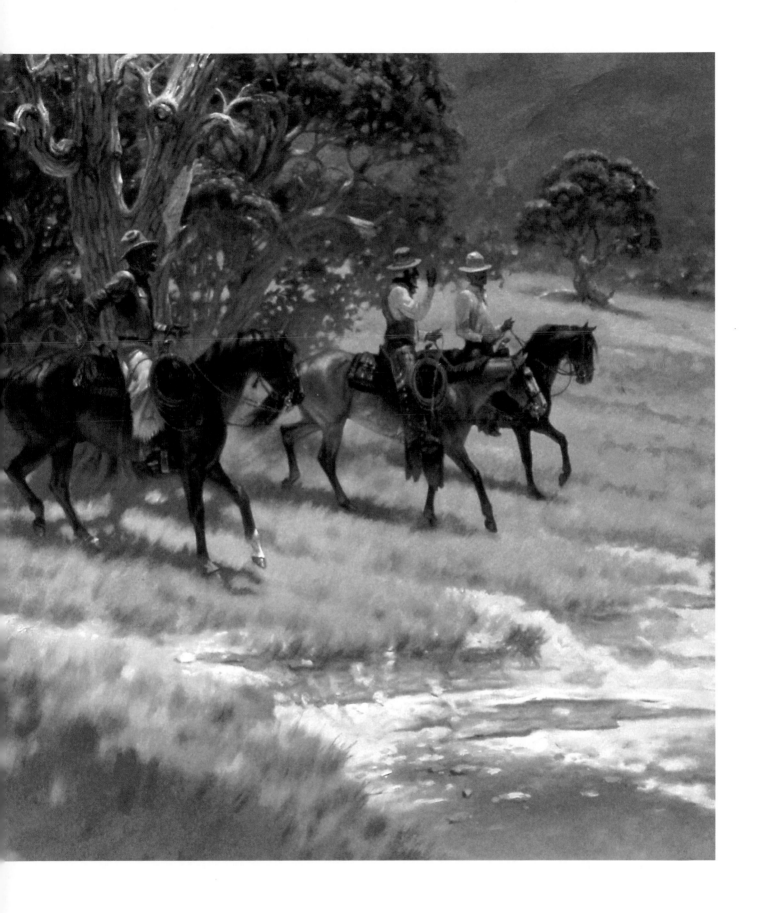

# Walkin' John

By Henry Herbert Knibbs

Walkin' John was a big rope-hoss, from over Morongo way;
When you laid your twine on a ragin' steer, old John was there to stay.
So long as your rope was stout enough and your terrapin shell stayed on,
Dally-welte, or hard-and-fast, it was all the same to John.

When a slick-eared calf would curl his tail, decidin' he couldn't wait,
Old John, forgettin' the scenery, would hit an amazin' gait;
He'd bust through them murderin' cholla spikes, not losin' an inch of stride,
And mebbe you wished you was home in bed—but, pardner, he made you ride!

Yes, John was willin' and stout and strong, sure-footed and Spanish broke,
But I'm tellin' the wonderin' world for once, he sure did enjoy his joke;
Whenever the mornin' sun came up he would bog his head clear down,
Till your chaps was flappin' like angel wings and your hat was a floatin' crown.

That was your breakfast, regular, and mebbe you fell or stuck.
At throwin' a whing-ding John was there a-teachin' the world to buck.
But after he got it off his chest and the world come back in sight,
He'd steady down like an eight-day clock when its innards is oiled and right.

We gave him the name of Walkin' John, once durin' the round-up time.
Way back in the days when beef was beef and John he was in his prime;
Bob was limpin' and Frank was sore and Homer he wouldn't talk,
When somebody says, "He's Walkin' John—he's makin' so many walk."

But shucks! He was sold to a livery that was willin' to take the chance
Of John becomin' a gentleman—not scared of them English pants.
And mebbe the sight of them toy balloons that is wore on the tourists' legs
Got John a-guessin'; from that time on he went like he walked on eggs.

As smooth as soap—till a tourist guy, bogged down in a pair of chaps,
The rest of his ignorance plumb disguised in the rest of his rig—perhaps,
Come flounderin' up to the livery and asked for to see the boss:
But Norman he savvied his number right and give him a gentle hoss.

Yes, Walkin' John, who had never pitched for a year, come the first of June,
But I'm tellin' the knock-kneed universe he sure recollected soon!
Somebody whanged the breakfast gong, though we'd all done had our meat,
And John he started to bust in two, with his fiddle between his feet.

That dude spread out like a sailin' bat, went floppin' acrost the sky;
He weren't dressed up for to aviate, but, sister, he sure could fly!
We picked him out of a cholla bush, and some of his clothes staid on;
We felt of his spokes, and wired his folks. It was all the same to John.

**After a Hard Day**
By Craig Sheppard

*Craig Sheppard* (1913-1978) was born in Lawton, Oklahoma, in 1913, six years after that territory had become a state. He was a cowboy and rodeo rider who rode bulls in Madison Square Garden. He attended the University of Oklahoma and became an art teacher, eventually making his home at the University of Nevada, Reno. He received a Fulbright award to lecture at the University of Oslo, Norway, on Native American art. His watercolor series, "Landmarks of the Emigrant Trail," explores traces of the old Applegate-Lassen Trail across northern Nevada. He liked painting in brush and ink and shared his studio with his wife, talented sculptor Yolande Jacobsen Sheppard. His daughter Sophie is also an artist (see page 84).

# Homesteaders, Poor and Dry

By Linda Hussa

The world was bone dry.
I don't know why God would do such a thing.
The field was bare as the floor
And the springs nothin'—nothin'.

Papa's cattle bawled night and day
    till I thought I'd go crazy with it.
    Turn them out, I cried.
    Kill them, Papa, I begged.
    And he did.
    And he killed himself, too, in a way
    'cause he loved them crazy ol' cows.
I had to help him.
There wasn't anybody else.
    Momma had the baby.

He handed me the big knife
    and I followed him.
First he took the red one,
    the one he didn't like the most.
    Old Mule, he called her 'cause she kicked him every day.
He coaxed her into the barn.
She went hoping for some hay.
The barn still smelled like hay,
    so she went.
He tied her up
    and took the knife from me
    held it 'round behind his back.
    He thought she'd know what he was up to,
    and run.
He slipped his arm around her neck
    and the knife came up
    sharp and glinting
    like a present.
His hands were shaking.
He had killed cows and pigs and chickens
    millions of 'em
    but his hands were shaking now.
This dry had him half crazy too.
Just when I thought he wouldn't do it
    he screamed

and I screamed
and old Mule screamed.
She pulled back
and her wild eyes looked right at me.
Blood thumped out of her and she fell
shaking the ground under me
as if I was going, too.

Papa was on his knees crying,
    I'm sorry old Mule, I'm sorry,
    and I ran away.
I threw the gate open
    and chased the other cows away.
    I didn't know where they'd go,

## The Gate
By Patty Fox

*Patty Fox* is a professor of art at Great Basin College in Elko, Nevada. Her work is available at the Western Folklife Center and Northeastern Nevada Museum in Elko. (patty.fox@gbcnv.edu)

but somebody else could kill 'em.
Not my Papa.

The next week the well went dry.
Papa would drop the bucket down
   and it would come up empty.
He turned the bucket over and the bottom was wet.
He said I'd have to go down in the well
   and fill the bucket
   with a cup.
I'd have to
   'cause we could never pull him up.
He was the strongest

and the well was small
and I was the smallest.
No Papa. I can't.
Yes, you can, girl. You can do it for the baby.
He tied a stick in the rope
   for me to stand on
   and boosted me over the side.
I could only see a few feet down
   then there was a black hole
   and I was looking into the belly of a monster.
  A monster that would take me in one swallow
   and I didn't even get to have my own baby and home
      yet.

*(more)*

**Barnyard** By Patty Fox

The well was so narrow
    the walls brushed me.
    It was dark
    and places big rocks stuck out and scraped me.
    I cried let me up
    let me up
    but I was still going down,
    leaving the world
    leaving Mama crying my name
    and my Papa moaning, it's for the baby, girl.

I was lowered down in that well every day
    'til the drought broke.
    Every day.
    I closed my eyes and sang myself songs
    dipped the water raising down there in the pitch
        dark
    all by the feel.
But there was no time I'll remember
    like that first time.
After, when the water came back up in the well
    I went and looked down into the water
    and imagined myself on the bottom
    and sometimes I wanted to go back down
    to the quiet of the dark.

His face brushed mine
and I whispered, No Papa.
No.
But the rope was sliding over the edge
and I was going down too.
I clung on to that rope
    nothing could get me loose
    There were things down there.
    Scary things that would touch me.
    Papa's face in the circle of sky went farther away
until I couldn't see him
    only a black circle in a blue circle
    getting smaller.

In all my life
    Nothing can make me scared.
    I went down into the earth
    and drew back up.
    Nothing can ever scare me again.
    No man.
    No beast.
    No God.
I saw his face that day
    and He promised me
    no fear.

# Observations on a Sunday Walk Home

By John L. Moore

What we have here is a burst of deer
and over there a sliver of snakes;
down by log a chorus of frogs,
and a howl of hounds at our flanks;
a cackle of crows in cornfield rows,
a bellow of cows in the bend;
a swish and a whoosh of runaway wind,
and a squall of cats in the end.

# Miles City!

By John L. Moore

You are the skull of a poorly wintered cow,
poor as not prepared for storms you ignored
by thinking them borders of your pastureland.

Your leather-handed gods have left you.
Exiled in the shadows of Main Street bars
they grimace holding a fading storefront
as the haunting cries of young men's laughter
swirl in the hollows of their eyes.

You pound nails into their hands.
Spikes of plastic and neon
that bind the sun when it seeks retreat
through a blood-red door in the west.

Miles City!
Worshipper of false idols,
your prophets are bound by barbed-wire visions,
their horses stand idle in corrals of decay,
the apostles are framed in museum displays
caged as a wind with tourists sucking their breath.

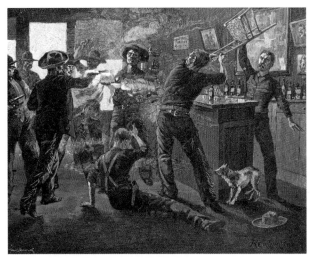

**A Row in a Cattle Town**
By Frederic Remington

Cowtown, you are dying.
Only your posture keeps you from falling.
You whittle now on the ankles of change.
You whittle now on the anklets of chains.
Release me, you cry.
Release me until the last old man in the Stockman Bar
    has uncinched his saddle and died.

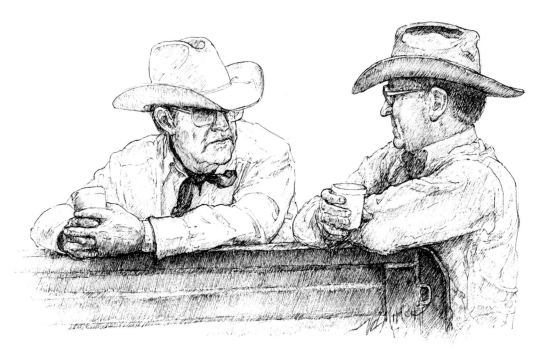

**Talkin' Horses**
By Vel Miller

# My Grandfather's and Father's Horses

By Shadd Piehl

The two old-timers stand out west of town
With maybe a few cows to share
A bale and ground feed each morning.
King, over thirty, is swaybacked, slow
And still impossible to catch
(except by tricks, women and oats).
Cheese, once a terror in the corral,
Now no longer rules the roost.
In their old age they shy,
Meeting themselves in shadows
At the water trough.
Both needing their teeth floated,
Dun horses out to pasture.
Every cowboy has a horse that's not for sale.

# Fiddles

By Leon Flick

There's something almost mystical
In them magic fiddle tunes,
Like swans, a flyin' overhead,
And callin' to the moon.
Like a bull elk calls his challenge
Or a coyote changes keys,
There's something in them fiddles, boys,
That makes you tap your knees.
Well, they picked the Harp for Heaven's Door,
But folk's let me tell you what.
I hope in Western Heaven,
They got them fiddles, sawin' hot.

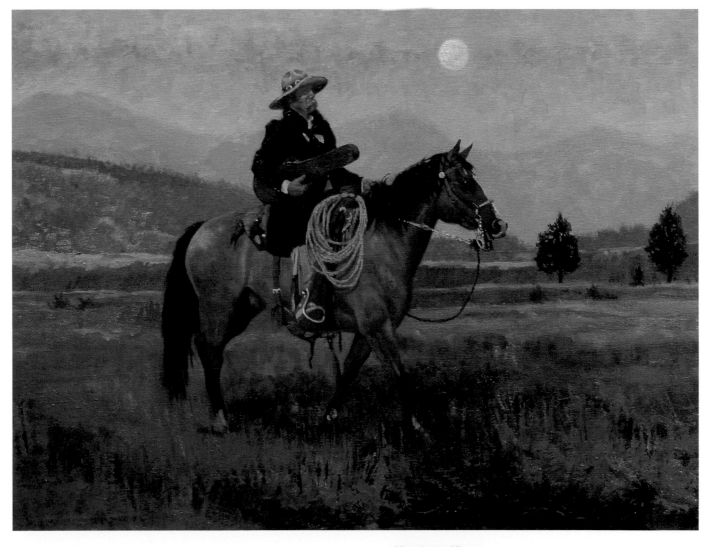

**Montana Moon**
By John Phelps

# Trilogy for Cissy

By Larry McWhorter

It's a breezy ten degrees, December 1985
The hooded rather slow-looking boy walks down the street,
Carrying an egg crate. Not a disturbing sight, but unusual.
Unable to resist my own wit
I quip, "Yer yolks'll freeze, boy."
"T'aint eggs," he mutters, opens the box,
Changes my life.
A face which couldn't decide whether to be blue or white
So it split the difference
Popped out like a jack-in-the-box.

Scrambling atop her siblings to reach me,
Hindered by stubby legs, a pot belly
She failed at leaping into my arms, but found her mark in my heart.
Eyes so intelligent I felt inferior said,
"I need a home and you're it, pal."
Defeated, yet needing to make a stand I said,
"I don't need a damn dog.
But Holly does."

■ ■ ■

June 1986 finds me mounted on a weekend warrior's excursion.
An enthusiastic yet obedient pup
Follows Frank and me in search of footrot.
I fall in on a steer and so does she.
"Cissy, get back here," I yell, and point behind my horse.
She stays there the rest of the day.
At home I gaze on her sleeping form
And feel her dreams resemble mine:
She did so well,
And my eyes cloud with knowing
She'll never be what she was meant to be.
Alone at Dad's, Holly, asleep on the couch,
Is suddenly awakened by a snarling brute
Which resembles our cordial pet in size and color only.
Two intruders, friends of Dad's,
Stand at the doorway, hats in hand.
Cissy straddles my startled wife
Raised hair and bared teeth say, "Mine."
A misunderstanding, but a point made.
As we visit I watch her at play with the villains,
Now victims of Fetch
All is forgotten but by me
No code words or trained reaction
No accidental robotic attack

A purely protective act of agape love
Which cannot be bought, only given.
No longer the family pet, she is now a family member,
Status earned through rite of passage,
All too often failed by true blood kin.
She puts her ball in my idle hand and dares it to escape.
It makes a valiant attempt, but fails again.
She returns with the fugitive.
My thoughts return to an earlier day:
She did so well. My eyes cloud
With knowing I'd been wrong.
She is exactly where she was meant to be.

■　■　■

"Mr. McWhorter, Cissy's up here again."
"Sorry for the bother, I'll be right up."
"No, no bother, she's playing with the kids,
Just letting you know she's here. Goodbye."
Chuckling, I hang up the phone.
How many such calls? No idea
Ambassador, guardian, babysitter, clown:
Five hundred dollars laughed at once.
Like me a social gadabout,
New acquaintance or old friend, she sees no difference,
Always visiting her only vice.
Trusting luck, I allow it
Over the protests of my wife.
Too much freedom, too near the road,
But she never goes near it
Until today. A drizzly September day, 1991.

Recent rains make for easy digging for the first foot or so.
Then I hit the rocks.
My rock bar pounds mercilessly, steadily,
In through the blameless truck-driver's brain.
"I told you so" pounds mercilessly, steadily into mine.

The grave is two hours in the digging.
The collar hanging on the black walnut's
Limb, a hatefully silent mound of black dirt:
All I've left of a precious child I loved too much to contain.
Kneeling beside the end result of five years' love and training,
I wonder how many grieving parents have wept those exact same tears
For the exact same reason.

# Leaving Camp

By Randy Rieman

Spring's a distant memory now
The green grass turned to brown
The scattered leaves of aspen trees
Blow golden 'cross the ground

The larkspur and the lupine
Are faded out and gone
And ice has formed along the banks
Down at the beaver ponds

An early autumn snowfall
Has whitewashed distant peaks
And the cattle sensing winter
Leave the high ground in retreat

The snow will melt 'neath autumn's sun
Before it comes to stay
By the warnings made and heeded
We know winter's on its way

The circling of the sandhill cranes
Reminds us that it's time
To be moving off of summer range
And leaving camp behind

The season's nearly finished
Like the cranes, the time flies by
We'll soon be rollin' up our beds
And shaking hands goodbye

So we linger on the ridges
In the sunset's parting rays
We walk and talk instead of trot
And try to stretch the days

These autumn days we cherish
While our youth is on display
They're the ones we know we'll long for
When we're burdened down with age

There's more than nature's beauty
I hate to leave behind
It's this man who mile after mile
Has ridden by my side

From the cold gray light of morning
'Til the long day's twilight end
A good and faithful partner
And a trusted lifelong friend

With a handshake and a few brief words
We'll wish each other well
Then both go our separate ways
To face the winter's chill

But leaving camp ain't easy
When it's shared with such a friend
The kind you've been to me, Todd
Hope we'll share camp soon, again

Vaya con Dios, amigo

*Randy Rieman says: "Todd was my riding partner on The West Fork Stock Association, a forest grazing permit on the West Fork of the Madison River in southwest Montana. We rode together for two seasons, from May through October, then guided elk hunters till December. They were good years."*

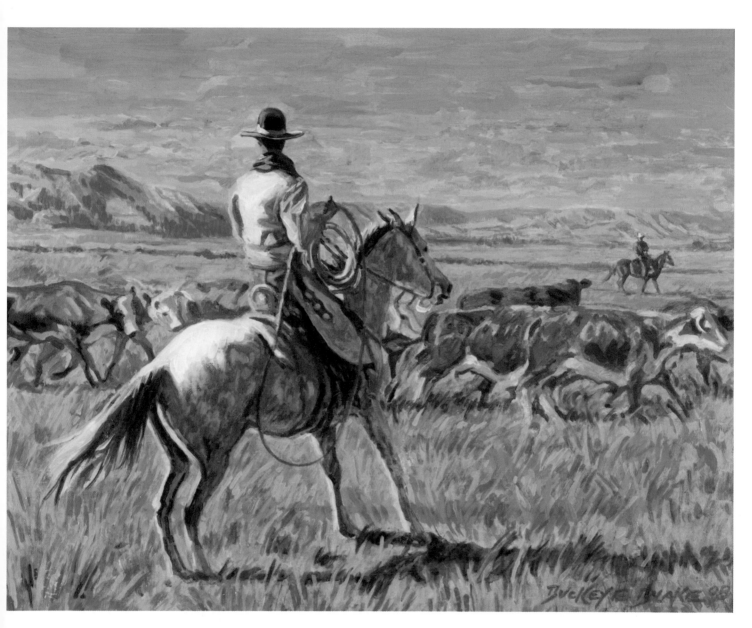

**Northern Range**
By Buckeye Blake

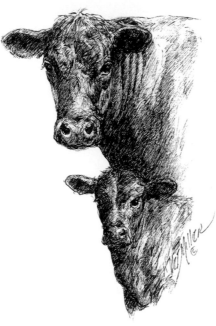

**The All Blacks**
By Vel Miller

# Early Turnout to a Dry Spring

By Carolyn Dufurrena

All the promise of the new season withers
In sullen gray clouds that refuse to share their moisture.
We raise our eyes to the north,
Scan skies for a promise of rain,
Breathe in the hope of that wet desert smell—
No.
Not today.
I feel like withering too, my insides hollow;
Sweat beads my brow on cold mornings, my body
Inexplicably out of tune.

Springs in the high country draw on old water deep inside;
I cross the ridge in January,
A skiff of dry snow dusting
The road I've only known in summer.

We open the gates. The calves gambol out
Kicking up dust where the fuzz of green grass
Should be.
I watch cattle turn back and look at me,
As if asking, "Now? Already? Are you sure?"

# Blue Moon New Year's Eve

By Carolyn Dufurrena

One joyous hour
Skidding in falling snow
Her snow pants wild with butterflies, pink parka smackeroo
Of whooping joy skittering on turquoise plastic
Down the hill into the feedlot alley, monochrome with winter,
Startling the heifers.
The storm lasts just so long
Time enough for one sledding,
One snowman.

Then it all turns to slush and shit,
Muddy boots, frozen pumps,
It's a feed-truck-won't-get-out-of-first-gear afternoon.

But that night,
Clouds drift by a big blue moon,
Coyotes howl in joy.
We dig the last of the Chinese fireworks from the back of the closet,
Drive out to the highway
So we don't run the horses through the fence.
Her dad's Zippo snaps Whistling Moon Rockets into life,
Screaming off into that snow-light desert New Year night.
We pour champagne into metal cups
Rattling on the hood.

Poof.
Blue on white on indigo,
Red on green,
Gold on silver,
Tinseling down the darkness,
Silences that coyote chorus.
I'm struck dumb too,
Remembering, soaked up
In that moment of silence
After the explosion of something,
Where you realize you only just exist
To fill this small space
In this endless midnight world
Lit by this giant midnight moon.

# Moon

By Hank Real Bird

The movement of the wind is held high
In the sky position of the moon
To foretell what the clouds bring for us.
The crescent returns she, apogee
Turns to see grandchildren in movements
With the earth in shadows of teepee,
For to rain or light snow to come by.
Granddad said cowboy too was in tune
With movements of the ground and the moon.

## When The Morning Sun Is Welcome
By James Boren

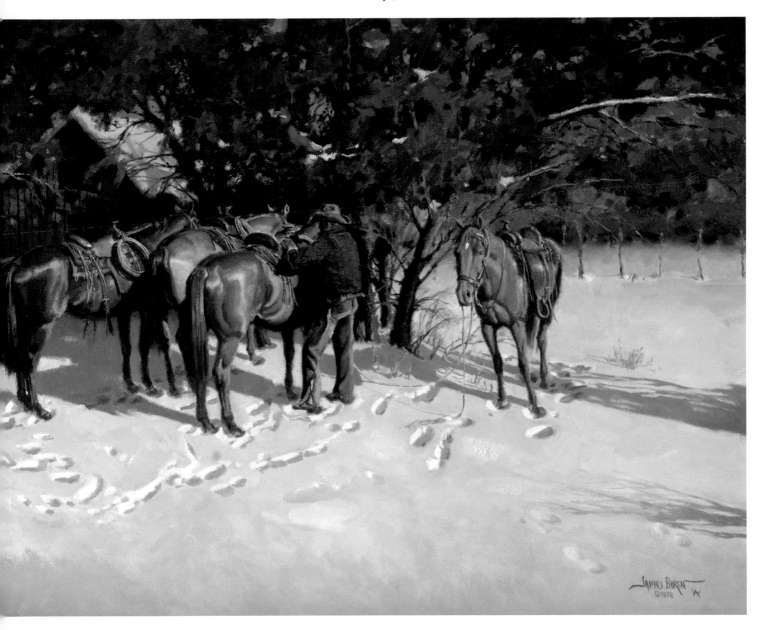

# Old Cow Dog's Winter

By Carolyn Dufurrena

11/25

Steady rain soaks the morning,
Gray curtain all but hiding nearer hills.

Red hen forsakes her nest
Across the yard, scolds old Cookie
To make room in that doghouse.

Two male robins
Preen foolishly in the yard
For mates long gone south.

Sick fawn shows herself
At noon: laggards of the season,
Given a reprieve
That ends today.

11/26: First snow

Skiff of white across dry grass;
Broken clouds hang low
and high.
Across the valley, sun
burns one blue patch
Above the storm's roiling remnants.

11/27: Seventeen degrees

Pearly light infuses dawn's gray cloud bank
Coyote lopes across the yard
Scattering fawns and pheasant.
Does gather, face him.
Dark shapes melt into red willow thicket.

11/28: Shipping

Chicken clucks annoyingly
At doghouse entrance, but
Old dog's gone early.

Heifers rumble on
To rickety old scale.
She crouches, ready.

By afternoon, she's
Bleeding from her gums,
The stove-up shoulder;
Cheekbone flowers bright red too:
Calves too fast these days.

Her boy's long gone,
But the work remains to do.
Cloudy eyes tell me her mission:
Stay here. Guard the house.
Help when there are cows to chase.
Die with your boots on.

So go ahead, chicken.
Lay your egg in her yellow nest.
She'll be home tonight,
And appreciate the morsel.

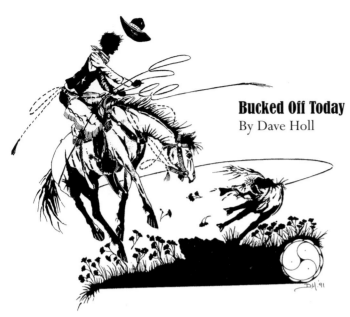

**Bucked Off Today**
By Dave Holl

# Family Branding

By Carolyn Dufurrena

Sunday afternoon,
All the kids are roping
Slurping lemonade between
throwing those big calves.
Growing up fast, all of 'em.

It happens fast,
faster than I can turn around.

I see you over there
Down on your knees
Across the lot,
Face gray in the spring wind.

See the horse, head high
His black mane flying like a victory flag
over an empty saddle.

In a minute, we're all there,
Except the kids, still back in the bunch,
Holding the herd,
Their ropes quiet,
Trying to see what happened.

Only a moment, twenty yards away,
but it doesn't look good.
You finish the day, rope lots of calves
on that bay horse,
but your face is gray
for a long time.

Three highballs into the evening
You still can't move, or breathe.
"Just wasn't payin' attention.
Switchin' ropes, dropped my reins,
If it'd been you or one of the kids,
I'd a given you hell
for what I did.

"Picked my spot too
But I still landed like a sack of shit."

Disgusted and sore, but mostly dismayed:
The years betray
what you know about yourself,
Bucked off today,
A month shy of fifty.

# Song of the Packer

By Joel Nelson

Down from the peaks and pinnacles,
And up from the canyon floor,
Through passes and fountains of immature mountains
Where big-hearted rivers roar

Comes a song that is mostly imagined
By the wildest stretch of the mind,
Only to blast out from some promontory
Like ten philharmonics combined.

Can you hear? It's the song of the packer
The ballad of man, horse, and mule
Who gamble on hands dealt by nature
Where earth and the elements rule.

It's a song of the mountains and timber,
And it's mainly a song of the West
From the man who still cargoes the sawbuck and
    Decker
The man, some say, hasn't progressed.

He's sold his soul to the mountains,
Though a good woman might own his heart,
And the two-diamond hitch that he throws on
    his canvas
Has the touch of Rembrandt's art.

And though his vocabulary
Rivals those of the sea and the sail,
He explains that his colorful language
Helps line out his mules on the trail.

But he's motherhood soft on the inside
And his very core feels a thrill
At the vapor that blows from the throat of an elk
As it bugles from some frosty hill.

Just look at the sling ropes and crowsfeet
And the picket line froze hard as sin—
See the axe on the side of the lead mule's pack
'Cause the trail is probl'y blowed-in.

See the product of evolution
Culmination of savvy and brawn
A legacy passed down from Genghis Khan's Army
The packers of history's dawn

Hear the music transcending the continents
And breeds and races and time.
The mountain man's national anthem
Is heard in the clank and the chime

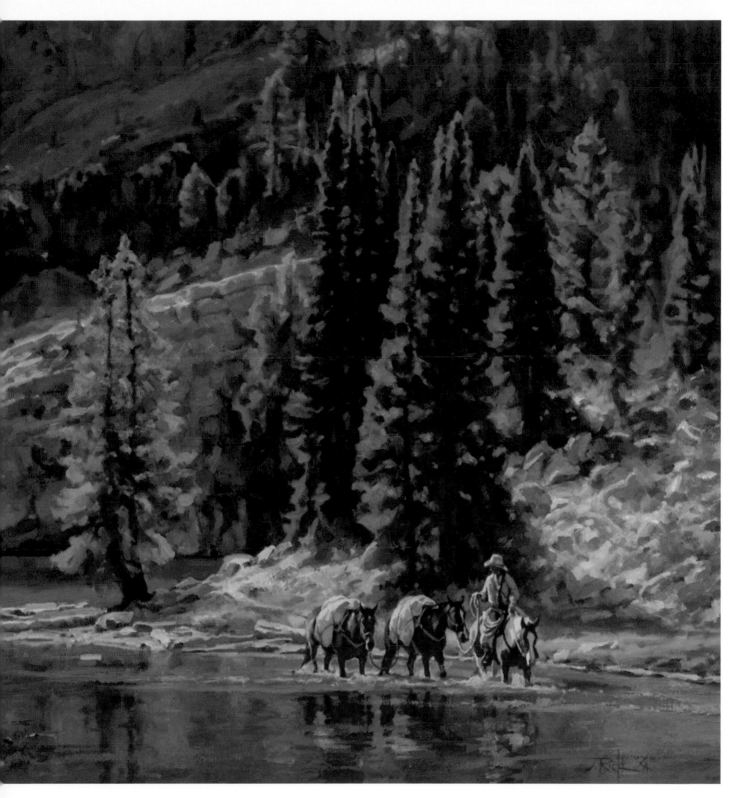

**Leaving Bloomington Lake**
By Jason Rich

Of the bells as they sway in the moonlight
On the necks of the trail-weary string—
In the raven's call, in the eagle's scream
And the metered rowel's ring.

The tempo is set to the seasons,
To the weather and geography,
Or the whim of an unpredictable mule,
And it's "classical music" to me.

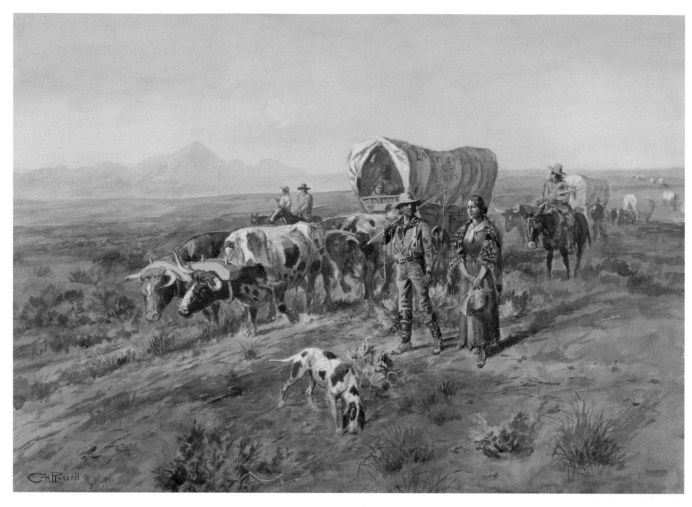

**Last Chance** By C.M. Russell

# Crossing the Plains

By Joaquin Miller

What great yoked brutes with briskets low,
With wrinkled necks like buffalo,
With round, brown, liquid, pleading eyes,
That turned so slow and sad to you,
That shone like love's eyes soft with tears,
That seemed to plead, and make replies,
The while they bowed their necks and drew
The creaking load; and looked at you.
Their sable briskets swept the ground,
Their cloven feet kept solemn sound.

Two sullen bullocks led the line
Their great eyes shining bright like wine,
Two sullen captive kings were they,
That had in time held herds at bay,
And even now they crushed the sod
With stolid sense of majesty,
And stately stepped and stately trod,
As if 'twere something still to be
Kings even in captivity.

# Stealing a Pig

By Jack Walther

We were at a livestock auction
In a town called Jerome
That is across the Idaho border,
About 170 miles from home.

A cow had calved last night
Out along the crick.
The calf slipped in the water,
Where it drowned pretty quick.

We figure to take a calf home
And put it on that cow.
There are lots of ways to graft a calf,
We'd make it work somehow.

A big red calf came through the ring
It looked healthy and strong.
My auction bid was very low
But we got it for a song.

We paid for the calf,
Backed up to the chute.
When we put the calf in the truck,
A pig ran on to boot.

We locked the old truck's endgate.
No one had seen us load,
So we got into that pickup
And headed down the road.

Coming down the highway,
We heard the radio say
That there had been a pig stole
In Jerome's saleyard that day.

It said they set up roadblocks
As the highway patrol sometimes does,
To stop and check all traffic
And find out where that pig was.

We stopped and put the pig in the cab,
Wrapped him up in Irene's coat.
The porker seemed to like that,
He was a gentle little shoat.

When we neared the roadblock,
I put my hat on his head.
We were plenty worried
Just wishin' we were dead.

Two patrolmen approached us,
Asked each of us our name.
It was Jack and Irene Walther,
So we told them the same.

There between us on his haunches,
That little porker sat.
His eyes and nose protruding
Out from underneath my hat.

One of the cops looked right at the pig
And asked him, "What's your name?"
The pig then grunted, "Oink."
I was about to die from shame.

The officer said, "Thank you.
You folks can go."
Sweat was drippin' from my brow
When I shoved that truck in low.

The patrolman said to his partner,
"If you know what I mean,
That Oink Walther
Is the ugliest person I've ever seen."

# Heading for the Railhead
By Steven Saylor

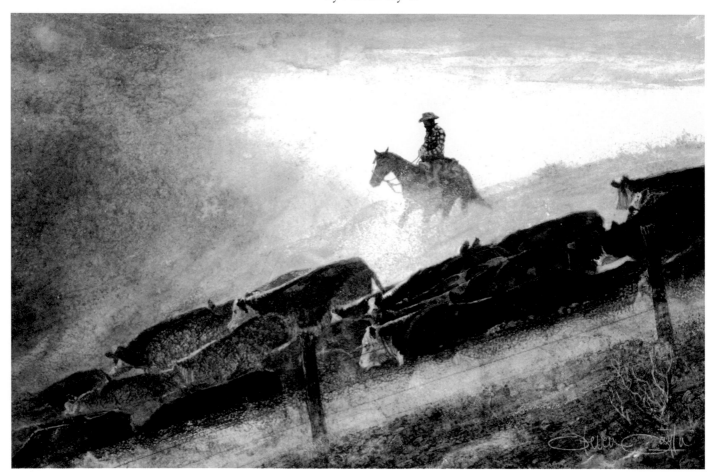

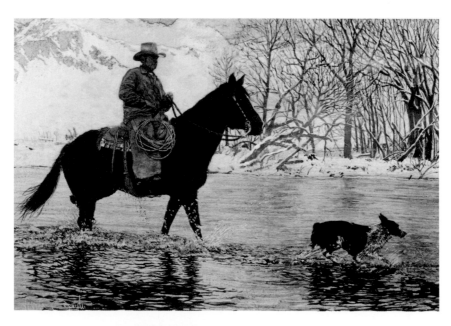

## Crossing the Carson
By Steven Saylor

# Nor A Borrower Be

By Linda Hussa

New pickup, shiny, clean pulls into the yard
    No hay stacked three tiers high
    No jumper cables or fix-it-all toolbox
        or handyman jack
        or wads of baling wire
        or cans of staples
        or hammer with pipe handle welded on
        or fork or shovel
        or pile of rusted chains
    No .30-30 resting between dining-out coyotes
    No old dog on the seat along for the ride.

A new pickup with three men inside
    shoulder to shoulder
    stiff clothes with ironed creases
    stiff faces with importance.

Walking out to meet them
    a man in worn clothes that know sweat, not starch
    rough hand
        that sends a loop surely
        pulls a colt sweetly
        seals a deal
        changes a wheel
        and bleeds
    is extended politely
    to men
        who won't meet his eyes.

Inside, the woman
    sets out cream and sugar and cups for coffee
    as if in welcome.

Banker's eyes that see past people
    to the bottom line
    dissect her books with retractable scalpels
    ask for supporting documentation she cannot find
    shame her ignorant, high school concepts
        disappearing cash flow
        five-year projections
        unrealistic budget
    as if
        the six-year drought
        rising costs
        doubling taxes
        market downturns
        found their origin somewhere in this house.

The brutal silence of retribution
    of computer models projecting failure to pay
    sell down or else
    as years of work wadded up in pages of red ink.

And when those men are gone
    two stone people
    in bitter silence
    the hurt so deep
    there is no solace
    in each other's arms.

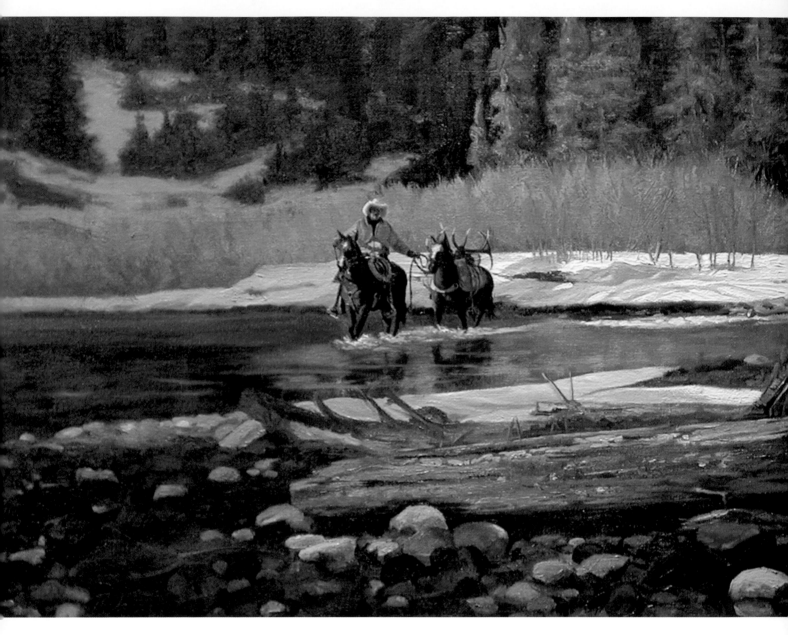

**Spirit of the Rockies**
By John Phelps

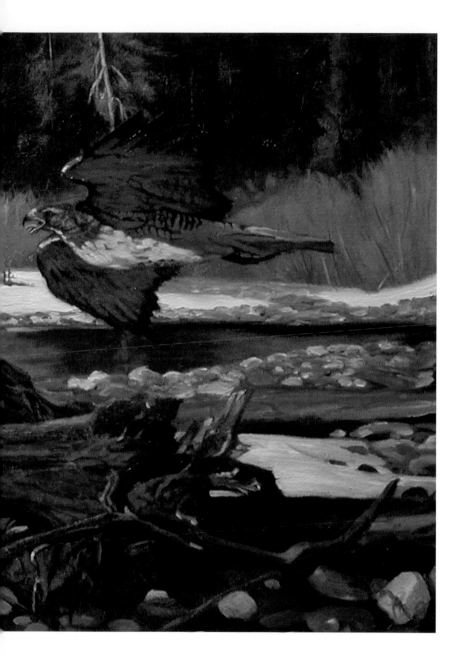

# Spring

By Vess Quinlan

A gentle agony,
Not really painful;
It does not tear,
But nibbles and complains,
Like a child too tired to eat.

I am not frightened or confused.
I know what it is;
Know I can suppress and survive it.
But I should be impatient,
Pushing winter on its way
Wanting the brown earth to crawl out
And awaken from its white sleep.
I should be looking for tender
Green grass on south slopes,
Worrying about late storms,
Men, tractors, wind,
Wet calves, scours,
And getting heavy ewes in at dark.

I have no worries,
Only an annoying tension growing
Stronger as spring approaches.
It is nearly planting time,
And I am in the city.

# War Poems by Cowboys

## White Wall
By Rod McQueary

There ought to be another wall
White, bright, and pretty
In a grove of trees
    with picnic tables,
    dance floor, and a
Viet Vet ragtime band.
A happy place where
    Folks could go to laugh
    and dance and argue
Football teams and candidates.
On the White Wall, there would be
A tremendous list of those
    Who didn't die.
Behind each name,
    a little heart…for a fulfilling marriage
    a little happy face…for a
    well-adjusted child,
    a little diploma…for a valuable education,
    a rewarding life.

Everyone is welcome here,
To cool drinks, rummy games,
To meet interesting people who
Talk, laugh, have fun, wander off.
    Live.
To celebrate our survivorhood.
Not mourn our stolen martyrdom.
There are some who will
Have to be shown
The White Wall.
Taken to their own name
and told,
"There, by God, is proof."

## Sweet Dreams
By Rod McQueary

the world comes crashing back
wire tourniquet
around your chest
and skull
blood pressure gauge
needle pegged
sitting up
wild fists slinging
sweat
go heavy
the swirling pictures
melt and shrink
the evil
you can even taste
and smell
unhooks greedy fangs
retreats reluctantly
from bedside light
like starving jackals
from a fire
this strange and crazy place
slowly becomes
familiar

she's awake
cowers
watching
says
what is it
what in the hell
is it
and when
you don't answer
she thinks
good god
he can't
even talk
but you're thinking
babe
the last
last
last thing you
need
is a good clear
picture
of what
I just
saw

# For Souls
By Rod McQueary

Perhaps,
He said, it's not a man's heart or mind
That drives him down to the surging sea
To straining mast.
Not mind, he said, that makes him fill
Some quivering stirrup     eagerly
To float out across the grunting
Pounding range,
Hat fanning reckless, loose and high.
Not mind that sends him high
    beyond the tether of the wind    or cloud,
Spear through the air to ride the sky,
    ascend the stairs, forsake the sod
To loose the reins and challenge    proud
Or taste the salty tears of God.

Perhaps it's not the heart     or mind
That spurs us on from thrill to thrill
But fluttering soul     stretching, straining,
Caged by ribs and blood     but still
Impatiently     but uncomplaining
Hopes for some escape to find.
Beneath some struggling bronco's death
In some tortured metal fuselage
Or sinking calm 'neath raging wave
Past the pain     and fear     and breath
We learn how new-freed souls behave.
Released now by this mortal's death
Unconfined by time or space,
Brighter, lighter, upward cast,
Newborn, it wakes in some chromed tunnel
Just beyond Medusa's face
And wonders why—It's free     at last.
Great God almighty     Free
       …at last.

**Familiar Things**
By Vel Miller

# Five Days Home
By Bill Jones

My father and I
Sit in the shade
Of a chinaberry tree
Talk softly about the last good war.
A time of ration cards
And Gold Star Mothers.
"A uniform meant free drinks
And a lot more,"
My father says.
"But they kept me training pilots
Stateside…
And wouldn't let me go."

In the lower pasture
A phantom chopper whines
Rotors thrash hot wind
As it wobbles upward
With another half-dead cargo.
I blink the image away.

"I won't ask if you killed anyone,"
My father says,
"Because I don't want to know."
Just as well, I think angrily,
My personal count is a little hazy.

Like the pregnant woman at Gio Linh
(She never should have run)
Zapped by a battery of howitzers
Raising puzzling statistical questions.
How do I mark her?
One and a half? Two?
"Drop 100 meters," I whisper.
"Fire for effect."
"Roger that," the RTO replies.

Arm in arm
My father and I
Walk awkwardly toward supper
And the six o'clock news.

The chopper drones
Tilts plexiglass nose
To a hospital ship.
The woman at Gio Linh
Seeing her chance
Dashes like a sprinter
Legs pumping furiously
For a stand of scrub oaks
Behind the barn.
"It's a shame," my father says,
Climbing the back steps,
"You didn't get to serve
In a real
War."

# Sagebrush Hymn

By Trish O'Malley

Our lady of Artemisia
Desert Deity,
Some might question naming
A plant so seldom seen
In the company of trees
After the Greek Goddess of the
Wood.
But knowing Artemis as
"Virgin" in the archaic sense,
it seems all too sensible to me.

Those of us
Who choose to stay
In this landscape
Eventually notice
That they've become
"one unto herself;
belonging to no man,"
despite our desire
to rest in the shade
of another's limbs.

Our lady of Artemisia,
Blessed by your name
Fragrant be your leaves.

*John Bardwell has been painting
the high deserts of Nevada for nearly
fifty years. He lives in Reno.
(www.johnbardwell.com)*

# Make a Hand

By Linda M. Hasselstrom

"Make a hand!" my father hollered when my friends came down to visit.
Almost everyone I knew would come to help us, just so they
could nod when conversations turned to ranching. "Make a hand!" He didn't
care if they were men or women when we needed help. "This job's
beyond an old man and a crippled girl," he'd say. "Make a hand
and drive those yearlings up the chute so we can take 'em to the sale.
Your mother wants new carpet but I think I'll get a truck." Gender
issues didn't surface, not until we got around to branding.
Even then he didn't call them that. He'd just yell, "Make a hand,"
and startle a romantic poet who'd never had a callus, who spent
his nights consulting with his muse, a scribbler whose idea of work
was sitting by a candle sighing while he doodled at his latest
masterpiece, a villanelle on spring and love. "Make a hand!"
That skinny poet jumped an eight-foot plank fence when he heard it.

The writer grabbed a calf's tail—frozen short the night his mother
birthed him, March and forty-two below. An artist slammed the headgate,
flipped the calf and held him while I laid a red hot iron
against his ribs. Before that calf discovered his potential he had
lost them both; was branded, ear tagged, received his shots and lurched
away. The poet headed back to get another critter, jeans
still oozing with authentic green manure as Dad yelled "Make a hand!"
It's been six years or better since we closed the box, that narrow casket
where he finally took his rest. We tamped the yellow gumbo down
that summer, filled and tamped some more come spring. I planted wild blue flax,
brought plugs of redtop from the pasture, big and little bluestem. Found
a sego lily like the ones he brought my mother every spring.
The gumweed flourished, creeping jenny, thistles. When I yanked them out
barehanded, I could hear him mutter that I should be wearing gloves.

"Make a hand!" I hear him shout when I quit work and wander out
to see if I've got mail today. "Make a hand!" he bellers when
I sit to read a bit of some new book before I start our lunch.
"Make a hand!" he hollers when I'm waking or asleep. He treated
me no different than the son he never had. He scrimped and saved
and criticized until the day he died, dropping dead outside
the kitchen door the way he always said he wanted to.
He left the ranch to Mother, even though she hated it and had
no man to help her. I got nothing, but I helped her sort the mess
he left, found money in the rafters, deeds stuffed inside a garbage
can beneath the cellar steps. I put her money in a trust
so she could have the care she needs in that new nursing home in town.
I added up the debts and stood beside his grave and cussed him hard.
I took a deep breath, got a loan and bought the ranch. And every time
I step outside, I hear the echoes, "Make a hand!"

**Uphill Chase** By Tom Browning

# Deacon and the Dun

By Red Steagall

Ol' Deacon was a puncher, born a hundred years too late.
A top hand, and he sure as hell was tough.
His bed was in a corner, he had been there thirty years.
God help the man who rifled through his stuff.

I'd ridden lots of roundups when he didn't say a thing.
Was tho' the words were stickin' in his craw.
Don't know if he was crazy or a woman done him wrong.
I always tho't he's hidin' from the law.

Now Deacon cared for horses like no man I've ever known.
He lived to see the babies in the spring.
His favorite was a zebra dun—he raised him from a colt.
The old man pampered Dunny like a king.

Four of us was in the south camp through the winter
    months,
Me and him and Buck and Billy Joe.
The only thing he ever said to any one of us,
Was who would ride with who and where to go.

We were calvin' heifers in the Palo Duro Breaks.
A norther hit and started spittin' snow.
Was stickin' to the cedar where we rode along the rim.
The valley lay three hundred feet below.

Then Deacon saw a baldy heifer standing on a ledge.
She looked to be about a two year old.
Don't know if she was stuck there or she maybe lost her
    calf,
Was bawling like a banshee in the cold.

So Deacon took old Dunny down a little rocky trail,
I watched the horse and rider disappear.
Then just as I approached the rim, the heifer ducked her
    head,
And bounded up that trail just like a deer.

Old Dunny tried to step aside and let the heifer pass.
The trail was narrow where they chose to meet.
Now Deacon knew they both would fall if he stayed in his
    kack,
Without him, Dunny might regain his feet.

Was at that very moment that she saw a little light
Between old Dunny and the canyon wall.
The old man left the saddle like an eagle takes to wing.
I stared in disbelief and watched him fall.

I had to ride the canyon rim until I found a trail.
It took forever pickin' my way down.
I found him by a cottonwood all rolled up in a wad.
Was breathin' but he barely made a sound.

Every single bone was broken, his eyes were all that moved.
He couldn't lift his head up, but he tried.
Through splintered teeth he asked me, "Son, did Dunny
    make it out?"
I nodded, he just smiled, and then he died.

Now in his stuff we found a dozen stories he had wrote,
'Bout horses he had ridden in his life.
But there was not a mention of his family or his friends.
No indication of a child or wife.

So what we know about him we can still put in my hat.
And tho' his story has a bitter end,
He could have jumped the other way, let Dunny take the fall
But Deacon gave his life to save a friend.

## Sandstone Sanctuary
By David Graham

*David Graham was born in Miles City, Montana, when his family was ranching in the Powder River area. His passion to paint the people, wildlife, and scenery of the West comes from deep roots. He lives in Billings, Montana. (www.davidgrahamart.com)*

# Hats Off to the Cowboy
By Red Steagall

The city folks think that it's over.
The cowboy has outlived his time—
An old worn-out relic, a thing of the past,
But the truth is, he's still in his prime.

The cowboy's the image of freedom,
The hard-ridin' boss of the range.
His trade is a fair one, he fights for what's right,
And his ethics aren't subject to change.

He still tips his hat to the ladies,
Lets you water first at the pond.
He believes a day's pay is worth a day's work,
And his handshake and word are his bond.

137

**Trailing Into Oregon**
By J.N. Swanson

**His First Lesson**
By Frederic Remington

# POET BIOS

J.B. **ALLEN** (1938-2005) of Whiteface, Texas, was a working cowboy for more than three decades. He was a frequent performer at gatherings, including the National Cowboy Poetry Gathering, the Texas Cowboy Poetry Gathering, Nara Visa, and the Arizona Cowboy Poets Gathering. His poetry is included in many anthologies; in his own books, including "Water Gap Wisdom" (1990) and "The Medicine Keepers" (which includes a CD); and on his recordings, "J.B. Allen: Classics, Kindred Spirits, and Treasures." "The Medicine Keepers" received the Western Heritage Wrangler Award in 1998.

Katie **ANDRASKI** (b. 1955) is the author of the poetry collection "When the Plow Cuts." She teaches English at Northern Illinois University.

Mary Hunter **AUSTIN** (1868-1934) was an American nature writer. She wrote several books, plays and poems about the lands and people of the High Sierra and the Mojave Desert, including, "The Flock," "Land of Little Rain," and "Taos Pueblo" with Ansel Adams, as well as an autobiography, "Earth Horizon." She famously disagreed with John Muir on whether to manage public lands as wilderness. Mount Mary Austin, in the Sierra Nevada, was named in her honor.

S. Omar **BARKER** (1894-1985) was born in a log cabin on a small mountain ranch in Beulah, New Mexico, the youngest of eleven children. He attended school in Las Vegas, New Mexico, was a Spanish teacher, high school principal, forest ranger, sergeant in World War I, trombone player, state legislator, and newspaper correspondent. He wrote close to 1,500 short stories and novelettes, 1,200 factual articles, and about 2,000 poems, for publications from pulp magazines to the *Saturday Evening Post*. He published five volumes of poetry, won the Western Writers of America Spur Award twice, and was the 1967 recipient of the Levi Strauss Saddleman Award. In 1978, he was the first living author to be inducted into the Hall of Fame of Great Westerners at the National Cowboy Hall of Fame.

Patty **BARNHART** (b. 1947) and her husband, Keith, are the owner-operators of Willow Springs Guest Ranch in south-central Oregon. To date, Patty has published three short story collections: "Make Mine With a Twist," "Let's Twist Again," and "Twisted," all available on Amazon.com. A number of her poems have escaped to the Internet and can still be found roaming the cyber highways as "anonymous." (willowspringsguestranch.com)

Virginia **BENNETT** (b. 1952) has worked on western ranches since 1971 with husband, Pete. She started colts for twenty years, and has drawn cowboy wages on big outfits. She has been performing cowboy poetry since 1988. Regularly featured at the National Cowboy Poetry Gathering in Elko, Nevada, she has also shared her work at the Smithsonian Institution,

and has been featured on PBS and NPR specials. She has authored three books of poetry and edited two anthologies. (www.bennettspurs.com)

Baxter **BLACK** (b. 1945) is a cowboy poet and philosopher, radio and television commentator, and a former bull rider and large-animal veterinarian. He has published over a dozen books of fiction, poetry, and commentary. He is a regular commentator for National Public Radio's "Morning Edition," hosts a syndicated weekly radio program, "Baxter Black on Monday," and writes a syndicated weekly newspaper column, "On the Edge of Common Sense."

William E. **BLACK** Jr. (b. 1946) has performed as a poet/storyteller, magician and master of ceremonies for shows throughout this country and in more than a dozen countries around the world. He has written and edited scripts, newsletters, educational programs, and technical articles, and has been published in regional and international publications. He has recorded three CD collections of western poetry. The most recent is "Cattlemen at the Cantina." (www.billblackaz.com)

Charles "Badger" **CLARK** Jr. (1883-1957) was the youngest son of a popular Methodist minister of the gold rush era who inherited his father's rich speaking voice but not his piety. He tried college but found it too confining, and spent six years in Arizona, where he fell deeply and passionately in love with ranching, cowpunching and what he called "the last of the old, open range." He earned the title of South Dakota's first poet laureate, but was largely unknown outside of his home state. He published seven

books, including: "Sun and Saddle Leather," "Sky Lines and Wood Smoke," and "Boots and Bylines," all available from the nonprofit Badger Clark Memorial Society, www.badgerclark.org.

Eleutheros **COOKE** (1787-1864) was a lawyer and U.S. representative from Ohio (1831-1833) who was born in Granville, New York. He served in the Ohio House of Representatives from 1822 until 1826, and in U.S. Congress as an anti-Jacksonian candidate. His son, Jay, was a prominent railroad financier.

John **DOFFLEMYER** (b. 1948) ranches on a tributary of the Kaweah River in the Sierra Nevada foothills of California. He began writing poetry at the age of thirteen. He edited *Dry Crik Review of Contemporary Cowboy Poetry*, an innovative periodical published by Dry Crik Press, from 1991 to 1994. He has served as poet in residence at California's University of Redlands. He is a featured artist on the Western Folklife Center's website and maintains an online journal, "Dry Crik Journal: Perspectives from the Ranch." His poetry addresses the endless battle of protecting farm and ranch lands from developmental interests. (www.drycrikjournal.com)

Carolyn **DUFURRENA** (b. 1953) is a rancher, writer, and educator in northwestern Nevada. She and her husband, Tim, live on the Quinn River Ranch south of Denio. She received the Silver Pen Award in 2002 for "Fifty Miles From Home: Riding the Long Circle on a Nevada Family Ranch," and in 2002, with Linda Hussa and Sophie Sheppard, coauthored "Sharing Fencelines: Three Friends Write from Nevada's Sagebrush Corner." A poetry collection, "That Blue Hour," followed in 2006. She has contributed prose and poetry to various anthologies, including "Crazy Woman Creek: Women Rewrite the American West" and "Unbridled: The Western Horse in Fiction and Nonfiction." She writes regularly for magazines and performs often at the National Cowboy Poetry Gathering. (www.carolyndufurrena.com)

Carmen William "Curley" **FLETCHER** (1892-1954) was born in San Francisco and grew up in Bishop, California. His many occupations included cowboy, poet, musician, rodeo promoter, publisher, and prospector. His most well-known work, "The Strawberry Roan," became a popular song and has a large history of its own, from bunkhouse to Hollywood. In Hollywood's world of make-believe, the cowboy poet was out of his element and often an unhappy man. One day when he was fed up with the film capital and lawsuits, he wrote, "Hell, I spent my best years as a cowboy of the old school...I still look back to long days and nights in the saddle, at thirty dollars a month, as the happiest of my existence."

Leon **FLICK** (1954-2013) was born in Gunnison, Colorado, and grew up on ranches near Lakeview, Oregon. He was a working cowboy his entire life. Leon and his wife, Billie, lived in Plush, Oregon, a small, high-desert town of sixty people more than 200 miles from the nearest freeway. He started sharing his poetry and stories in 1988 in Elko, Nevada, and entertained people in thirteen western states. His book, "Cow's Tail for a Compass," won the Buck Ramsey Award for Cowboy Poetry Book of the Year 2001 and the AWA Best Poetry Book of 2001.

Sunny **HANCOCK** (1931-2003) cowboyed all over the western United States and was in the vanguard of the cowboy poetry movement, starting with the first gathering in Elko in 1985. He performed at the Library of Congress and Smithsonian Institution. He won the Gail Gardner Award at the Arizona Cowboy Poets Gathering in Prescott, and was named Cowboy Poet of the Year in 2001 by the Academy of Western Artists.

Linda M. **HASSELSTROM** (b. 1943) is the author of fourteen books of poetry and essays, including: "Land Circle," "Dakota Bones," and "Bitter Creek Junction," for which she won the 2001 Western Heritage Award for Best Poetry Book. She is the editor, with Gaydell Collier and Nancy Curtis, of the anthologies: "Leaning into the Wind," "Woven on the Wind," and "Crazy Woman Creek." Her latest book is "No Place Like Home." A poet once said, "She can deliver a calf and a poem on the same day—after mending a fence." (www.windbreakhouse.com)

Linda **HUSSA** (b. 1941) lives in Surprise Valley near the small town of Cedarville, California. She and her husband, John, raise cattle, sheep, horses and the hay to feed them. She is the author of six books, including "Blood Sister I Am To These Fields," which won the Wrangler (National Cowboy and Western Heritage Museum), the Spur (Western Writers of America) and the Willa (Women Writing the West) awards. She is a member of the Western Folklife Center's Board of Trustees.

Bill **JONES** (b. 1948) moved to Wyoming to fulfill his cowboy fantasy after a career as a police detective. He worked as a dude wrangler, wagon-train cook, leased a small ranch, wrote three books of cowboy poetry, was a columnist for the *Wyoming State Journal,* and hosted a cowboy radio show. "Blood Trails," a collection written with fellow Marine Rod McQueary in 1993, was published by John Dofflemyer of Dry Crik Press. He and his wife raise Black Angus in Tennessee and own the gun and pawnshop in Harlan, Kentucky, that was used as the model for the television series "Justified."

He spends as much time as possible with his disabled son and hero, Iraq veteran Marine Chase Jones.

James **JOYCE** (1882-1941) was an Irish novelist and poet, considered to be one of the most influential writers in the early twentieth century. His complete works include the novels: "Ulysses," which parallels the episodes of "Homer's Odyssey"; "Finnegan's Wake"; and "Portrait of the Artist as a Young Man," as well as the short-story collection "The Dubliners," and three books of poetry, a play, occasional journalism, and his published letters.

E.J. **KIRCHOFF** (1913-1997) was born early in the twentieth century in eastern Oregon and lived his life working on ranches there. He began writing poetry in his youth by the light of an oil lamp. "My fascination with horses never abated," E.J. once said in later years from his home in Coos Bay, Oregon. He wrote and illustrated more than twenty of his own books. He illustrated "Legacy of the Land" for poet Virginia Bennett, who says, "E.J. Kirchoff was sure 'nough a real cowboy." His artwork was featured on a cover of *Dry Crik Review.*

Bruce **KISKADDON** (1878-1950) started out as a young cowhand and rough-string rider in the Picket Wire district of southern Colorado. He worked for legendary Arizona cattleman Tap Duncan for many years and also spent time droving in Australia. "Open Range: Collected Poems of Bruce Kiskaddon" (2007) includes almost all of his 481 poems.

Henry Herbert **KNIBBS** (1874-1945) was born in Clifton, Ontario, Canada, to American parents. He grew up spending summers on his grandmother's farm in Pennsylvania, developing a love of horses and the violin. He attended college in Ontario, graduated at age eighteen, and moved to New York state. Although he was never a working cowboy, he moved to California in 1910 and wrote thirteen western novels. He also published six books of poetry.

Margot **LIBERTY** (b. 1932) is historian of the Cheyenne Nation, a retired anthropology professor, and freelance writer living in Sheridan, Wyoming. She and her friend, John Stands In Timber, published "Cheyenne Memories" in the 1950s and it is still in print. In this work, they identified many sites where warriors fell during the Little Bighorn battle, and due to their dedicated efforts, markers are now placed there. Her most recent book is "A Northern Cheyenne Album." She has also authored a poetry collection, "Songs and Snippets," and produced a PBS film, "On the Cowboy Trail."

Allen **McCANDLESS** (b. 1800s). Little is recorded about him. Folklorist David Stanley

writes that he was "a working cowboy on the Crooked L Ranch in the Texas Panhandle." His poem, "Cowboy Soliloquy," first ran under McCandless' name in *The Daily Advertiser* of Trinidad, Colorado, on April 9, 1885.

Rod **McQUEARY** (1951-2012) was a native of Elko, Nevada. He grew up on remote ranches in the early 1960s, graduated in 1969, and soon found himself a military police officer in Vietnam. He struggled the rest of his life with post-traumatic stress disorder. He first recited his poetry at the Cowboy Poetry Gathering in Elko, Nevada, in 1986. In 1993, he and his friend Bill Jones published "Blood Trails," a book of poems based on their experiences in Vietnam. McQueary's other stories, many light-hearted and humorous, have been published in numerous anthologies. He and his wife, Wyoming legislator Sue Wallis, co-wrote "The Cowboy Cattle-log" and published "Surviving the Good Life," a memoir about Wallis' grandmother.

Wallace **McRAE** (b.1936) is the third generation of his family to run the Rocker 6 Ranch, a 30,000-acre cow-calf ranch in Forsyth, Montana. He is a passionate advocate for responsible use of the land and writes poetry in support of his beliefs. He is also very funny. His books include: "Stick Horses and Other Stories of Ranch Life," "Cowboy Curmudgeon," and "Things of Intrinsic Worth." He has received the National Heritage Award from the National Endowment for the Arts, the Montana Governor's Award for the Arts, and has served on the National Council of the Arts.

Larry **McWHORTER** (1957-2003) was reared on ranches in the Texas Panhandle. He attended high school in Canadian, Texas, and graduated from Clarendon College. He lived his dream of working for big ranching outfits and loved the pure cowboy life. In 1989, he began writing poetry which received national recognition. He was named Cowboy Poet of the Year by the Academy of Western Artists in 1998. In 1999, his album, "The Open Gate," was named Academy of Western Artists Poetry Album of the Year. His book, "Contemporary Cowboy Poetry," received a Westerners International Award and the Arizona Book Publishers GLYPH Award.

Joaquin **MILLER** (1837-1913), born Cincinnatus Hiner Miller, was an early western figure who influenced many of his time. While his life and his writings have been the subject of much criticism, he helped create some enduring Old West myths. A number of his popular works— "Life Amongst the Modocs," "An Elk Hunt" and "The Battle of Castle Crags"—draw on his experiences in the West. He moved to Britain where he became the popular "Poet of the Sier-

ras." He has been called a "poseur," "a vulgar fraud," and worse, and Bret Harte refused to publish any of his poems in his *Overland Express.* Still, at one time his poem, "Columbus," was memorized by many students.

Rod **MILLER** (b. 1952) grew up in Goshen, Utah, where his family ran a small herd of cattle and enough horses to keep everyone mounted. He rode bareback broncs in high school, college, and PRCA rodeos for several years. More than one hundred of his poems have appeared in print in *Western Horseman, American Cowboy,* and *RANGE.* He has published essays, articles, short stories, three novels, a poetry collection, and a chapbook. He is a member of Western Writers of America. His poem, "Tabula Rasa," and a short story, "Death of Delgado," have won Spur awards. He has also been Lariat Laureate of cowboypoetry.com.

Waddie **MITCHELL** (b. 1950) grew up on the Horseshoe Ranch south of Elko, Nevada, listening to cowboys' stories and memorizing their poems. He dropped out of school at age sixteen to become a full-time wrangler and chuck-wagon driver. In 1984, he and Hal Cannon organized the first Elko Cowboy Poetry Gathering. They were amazed that two thousand people attended. By 1994, attendance had soared to nearly 14,000. Mitchell recorded his first album of poetry at Cannon's house in Idaho in 1984. He released his second album, "Buckaroo Poet," in 1994. He has won numerous honors for poetry and storytelling, and is a member of the Cowboy Poets and Singers' Hall of Fame.

John L. **MOORE** (b.1952) is a third-generation cattle rancher near Miles City, Montana, and a multi-award-winning journalist and novelist. His journalism, book reviews, and photography have appeared in scores of publications. He has written eight books and is currently working on his sixth novel which is book four in the "Ezra Riley" series.

Joel **NELSON** (b. 1945) operates the Anchor Ranch near Alpine, Texas. He spent thirteen years at the 06 Ranch and as a horse breaker for the King Ranch in Texas and the Parker Ranch in Hawaii. An attendee at the second Cowboy Poetry Gathering in Elko, Nevada, he was instrumental in founding the Texas Cowboy Poetry Gathering, the second oldest of such events. "The Breaker in the Pen" is the only cowboy poetry recording ever nominated for a Grammy. In 2009, he received a National Heritage Fellowship for his poetry.

William Henry **OGILVIE** (1869-1963), poet and journalist, was born in Scotland, second of eight children. His father's family had managed estates in the Scottish border country for 300 years. Ogilvie went to Fettes College in Edin-

burgh. After college, he traveled in Australia for twelve years. Horse breaking, droving, mustering and camping out on the vast plains became the salt of life to him. He wrote hundreds of poems that were published in the *Sydney Mail,* the *Parkes Independent,* the *Australasian* and the *Melbourne Weekly Times.* His verses covered every facet of bush life. In 1901, he returned to Scotland, where he published eighteen books of Scottish verse and prose, including "The Collected Sporting Verse of W.H. Ogilvie."

Trish **O'MALLEY** (b. 1961) has had live-in love affairs with both the Snake and Starr valleys of Nevada. A former staff member at the Western Folklife Center in Elko, she is now an aromatherapist and energetic healer learning to paint who lives in the lush wine country of Northern California. Her favorite scent remains sagebrush after rain. (www.trishomalley.com)

Andrew Barton "Banjo" **PATERSON** (1864-1941) was an Australian bush poet, journalist and author. He spent much of his childhood in the rural district around Binalong, New South Wales. In 1890, as "The Banjo," he wrote "The Man from Snowy River," a poem which captured Australia's heart. In 1895, a collection of his works was published under that name. This book is still the most popular collection of Australian bush poetry. In his lifetime, Paterson was second only to Rudyard Kipling in popularity among living poets writing in English. He authored two novels, many short stories, and a book based on his experiences as a war reporter, "Happy Dispatches" (1934). His image appears on the Australian ten-dollar note along with an illustration inspired by "The Man from Snowy River," and, as part of the copy-protection microprint, the text of the poem itself.

Gwen **PETERSEN** was born in 1928 in Illinois and moved West in 1947. She has been a working rancher for over thirty years raising cows, sheep, pigs, and now miniature horses. She was one of the poets at the first Elko Cowboy Poetry Gathering, appeared on the Johnny Carson "Tonight Show," and has been featured several times at Elko over the years. She established the first Montana Poetry Gathering and "ramrodded it for the first five years." She has published half a dozen books, most recently, "Everything I Know About Life I Learned From My Horse" and "How to Shovel Manure and Other Life Lessons for the Country Woman." She has been dubbed "Erma Bombeck with some special problems with temperamental hired men, skunks and other varmints."

Shadd **PIEHL** (b. 1967) is a fourth-generation North Dakotan and third-generation rodeo cowboy who grew up near the Mouse River south of Minot. He has been a ranch hand, stockyard bird, hog hide shaver, warehouse

lumper, teacher, and saddle bronc rider. He has appeared at Elko's National Cowboy Poetry Gathering three times. In 2004, he was named an associate poet laureate by North Dakota State Poet Laureate Larry Woiwode. In 1999, he published a chapbook of poetry, "Towards Horses," with the magazine *Aluminum Canoe*. He is currently academic dean at Rasmussen College in Bismarck.

Vess **QUINLAN** was born in 1940 in Eagle, Colorado, and is part of the fourth generation on both sides of his family to raise livestock in rural Colorado. He began writing cowboy poetry during a yearlong bout with polio as a boy in 1951. He ran away from home at age fifteen and attended at least nine different high schools while doing chores morning and night for ranch families. His work has been published in many books and magazines, as well as on various online poetry sites.

Kenneth Melvin "Buck" **RAMSEY** (1938-1998) didn't know his real name until he started school because his dad nicknamed him Buckskin Tarbox when he was born. Buck always claimed he got his main education in a two-room schoolhouse in Middlewell, Texas. He graduated from Amarillo High School in 1956, knocked around from Texas to California and Canada, returned to Texas and kept cowboying until he was paralyzed in a horse wreck in 1962. Confined to a wheelchair at twenty-five, he taught himself how to play the guitar and started learning and performing the old cowboy songs. His epic poem about cowboy life, "As I Rode Out on the Morning," became an instant classic. "Grass, with essays on his life and work" commemorative edition and CD was released in December 2005. He received a National Heritage Fellowship from the National Endowment for the Arts and two Western Heritage Wrangler Awards from the National Cowboy Hall of Fame for his recordings.

Henry "Hank" **REAL BIRD** (b. 1948) is a rancher and educator who raises bucking horses on Yellow Leggins Creek in the Wolf Teeth Mountains of Montana. He was born and raised on the Crow Indian Reservation in the tradition of the Crow by his grandparents. He still speaks Crow as his primary language and feels this has helped him in writing poetry. In 1996, he won the Western Heritage Award from the National Cowboy Hall of Fame. He performs annually at the National Cowboy Poetry Gathering in Elko, Nevada. He has published six anthologies, five poetry collections, and twelve children's books.

Randy **RIEMAN** (b. 1955) has spent most of his life working on ranches from Montana to Hawaii. He trains horses, teaches horsemanship clinics, and is an accomplished rawhide braider. He is known for his flawless recitations of classic

American and Australian bush poets, and he writes a few poems himself. He has recorded two CDs: "Old Favorites: Classic Cowboy Poetry" and "Where the Ponies Come to Drink."

Everett **RUESS** (1914-1934) was a poet, artist and adventurer who traveled the remote American West in search of nature, encountering and engaging notables such as Maynard Dixon, Dorothea Lange, and Ansel Adams along the way. He disappeared in the canyon country near Escalante, Utah, in 1934. Although his burros were found near his camp, his fate remains a mystery. Used by permission, Gibbs Smith Publisher, from "Vagabond for Beauty."

Georgie **SICKING** (b.1921) started life in a cow outfit on Knight Creek, Arizona, forty miles from Kingman. Two years later she was horseback in the Arizona desert and by age seventeen she was on her own, roping wild burros, shoeing horses, competing in barrel races, and caring for cattle. After she married, she and her husband, Frank, ran ranches in California, Arizona and Nevada, where they raised three children. After Frank died, she continued running her own Brahma-cross cattle until The Nature Conservancy bought all the water rights surrounding her place. She sold out and began sharing her poetry. She has published three books, "Just Thinkin'," "More Thinkin'," and "Just More Thinkin'," and a CD, "To Be a Top Hand." She is the first Nevada member of the National Cowgirl Museum and Hall of Fame. In 2004, Far Away Films produced a DVD documentary of her life entitled "Ridin' & Rhymin'," which won Best Film About the American West at the Big Sky Documentary Film Festival in Missoula, Montana.

Jesse **SMITH** (b. 1941) grew up in Glennville, California, in the Sierra Nevada mountains. He has been a working cowboy all his life, starting out on the Tejon Ranch. He started writing poetry at an early age, and writes humorous as well as traditional poems. As one of the "Cardiac Cowboys," he released the CD, "Barely Live From Elko." He published a poetry collection with Sunny Hancock called "Horse Tracks Through the Sage." His song, "Dollar," won the 1995 CWMA Traditional Western Song of the Year.

Red **STEAGALL** (b. 1938) grew up in Gainesville, Texas. He rode bulls as a teenager, but at age fifteen was stricken with polio. He took up the guitar and the mandolin as physical therapy. He has published a number of acclaimed books, including "Ride for the Brand" and "Born to This Land," which won the 2003 Will Rogers Award. He has received nine Wrangler Awards for original music from the National Cowboy and Western Heritage Muse-

um in Oklahoma City. He is a member of the Texas Trail of Fame, the Texas Cowboy Hall of Fame, and the Hall of Great Westerners at the National Cowboy and Western Heritage Museum in Oklahoma City. In 1991, he was named the official Cowboy Poet of Texas by the Texas Legislature.

Luci **TAPAHONSO** was born in 1953 to Eugene Tapahonso Sr. of the Bitter Water Clan and Lucille Deschenne Tapahonso of the Salt Water Clan, one of eleven children. She received her Master of Arts in Creative Writing and English in 1982 from the University of New Mexico, where she currently teaches. She is the author of five books of poetry, including "Blue Horses Rush In," which was awarded the Mountain and Plains Booksellers Association's 1998 Award for Poetry. In 1999, she was named Storyteller of the Year by the Wordcraft Circle of Native Writers. She is the Navajo Nation's first poet laureate.

Jack **THORP** (1867-1940) collected cowboy songs and poems across the West for nearly twenty years, starting in the late 1800s. He first published them in 1908, in a small book called "Songs of the Cowboys." The next edition of the book in 1921, was greatly expanded and included over 100 songs and poems, including twenty-five pieces written by Thorp. He later published "Tales of the Chuck Wagon" and "Pardner of the Wind: Story of the Southwestern Cowboy."

Laurie **WAGNER BUYER** (b. 1954) is the author of seven collections of poetry, a novel, "Side Canyons," and three memoirs, "When I Came West," "Rough Breaks," and "Spring's Edge: A Ranch Wife's Chronicles." She has received the Beryl Markham Prize for Creative Nonfiction and the Western Writers of America Spur Award in Poetry. She and her husband, W.C. Jameson, live in Llano, Texas.

Sue **WALLIS** (b. 1957) is a writer and poet who ranches with her parents, Dick and Myrt Wallis, and her brother, Frank. She lost her beloved husband, Rod McQueary, in 2012. She has three grown kids, four stepkids, and four grandkids. She serves as the Wyoming state representative from Campbell County. (www.suewallis.blogspot.com)

Jack **WALTHER** (b. 1919) has spent most of his life ranching within a long day's horseback ride of his hometown of Lamoille, Nevada. At age eight, he started his first horse. He has been called one of the best cattlemen in the United States. He began writing poetry in the 1950s but kept it quiet. His work echoes themes repeated around campfires during the first cattle drives. He recites the poetry of classic cowboy poets as well as his own.

# Epitaph

By Margot Liberty

She never shook the stars from their appointed courses,
But she loved good men,
And she rode good horses.

## Partners

By Nancy Boren